IMAGES OF LIFE, CHANGE & BEAUTY

IMAGES OF LIFE, CHANGE & BEAUTY

Photographs, Poetry & Art

Selections from the works of
Fran Dalton,
Newburyport, Massachusetts

Compiled by Frank P. Stiriti & Colleen H. Stiriti

Peter E. Randall Publisher
Portsmouth, NH
2022

Primary source material from the
Fran Dalton Collection
Compiled by Frank P. & Colleen H. Stiriti

ISBN: 978-1-937721-91-6
Library of Congress Control Number: 2022913385

Peter E. Randall Publisher
5 Greenleaf Woods Drive, Suite 102
Portsmouth, NH 03801

Book design by Tim Holtz
Printed in Canada

This book is dedicated to the people of
Newburyport, Massachusetts, and all those
who knew and cared for Fran.

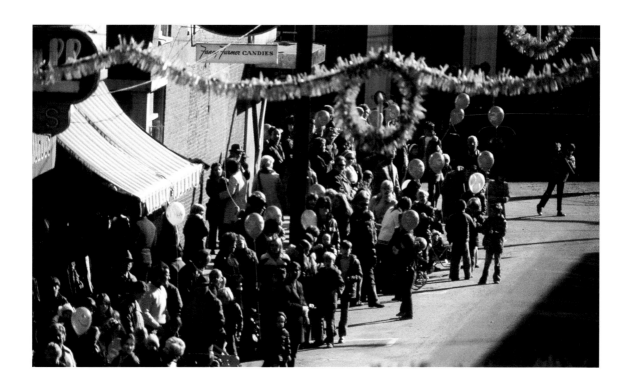

Acknowledgements

A special thank you to Sharon Spieldenner, archivist, Newburyport Public Library, and Marge and Skip Motes, historians and authors, for their interest in Fran's work from the first day we met, through the research process, and to the final draft of the book. You each encouraged us all along the way. We are especially indebted to you for your suggestion to include some of Fran's poems and sketches in the book to showcase Fran's many talents. The book was greatly enhanced by their addition and connecting them with photographs was an enjoyable task.

Shortly after our arrival in Newburyport, Covid-19 appeared and hindered our plans to reach out to many of the people who knew Fran. Even so, we were fortunate to connect with the following who made edit suggestions, informed us of preferred trans pronouns, shared their knowledge of the publishing world, or critiqued the selections of photographs for the proposed book. We are grateful for all your input. Thank you!

Thank you to all who shared your memories of Fran, whether it was in a brief conversation or for an afternoon full of stories. We appreciate your willingness to remember and celebrate Fran with us.

Jeffrey Briggs, Lindley Briggs, Eileen Chavez, Gus Colburn, Linda Dahlberg, Jean Foley Doyle, Roger Ebacher, Marcia Foley, Jack Garvey, Janet Hickey, Nancy Hocking-McDonough, Sue Little, Mary Lyon, Paul Lyon, Mary Manzi, Lois McNulty, Greg Nikas, Alan Schutz, Anna Smulowitz Schutz, John Sheedy, Debbie Szabo, Tom Szabo, and Sam Szabo—we very much enjoyed the time spent with each of you.

Lastly, to all our friends and family members who believed in our endeavor to promote and preserve Fran's legacy, and who expressed interest in our progress, we thank you.

Frank & Colleen Stiriti

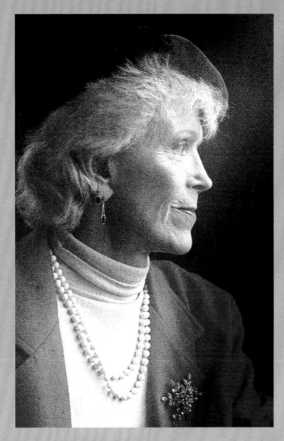

Frances Martina Dalton
October 17, 1928 – July 17, 2010

Introduction

It was 1960 when Fran Dalton arrived in Newburyport, Massachusetts. She lived in a local boatyard and supported herself diving for salvage and doing odd jobs. During this time she studied various media, including film photography, writing, art and sculpture.

Fran became a freelance photographer and was a popular figure around the city. Her camera was always ready to capture children at play, people at work, or an interesting composition. She dedicated herself to sharing her experiences and her love of nature, people, and places through her photography, her poems, and her artwork. Fran's work frequently hung in Boston and Newburyport galleries. She produced slideshows about the Merrimack Valley and its people, about Ireland, and whimsical shows for children, often using her own poetry and prose. Commercial work and portraiture were added to her portfolio in later years.

By 1970, Newburyport had become a city of boarded-up stores with a bleak future. The demolition of downtown buildings began with the arrival of federal urban renewal funds. However, the concept of a restored downtown captured the imagination of a group of citizens who then led the effort to halt demolition. They were successful in their goal and Newburyport's historic Federalist buildings were saved and restored. Fran Dalton documented, with her photographs, Newburyport as a downtrodden city in the 1960s, a city in transition in the 1970s and 1980s, and the restored and vibrant city it became and that it is to this day.

Fran also began her own personal transition. Having been born "as though a male" she took steps in the mid 1980s, at the age of fifty-eight, to live fully as her true self, a woman.

Fran's story of her journey in her words…

Ever since I was tiny I was preoccupied with being, in plain language, a GIRL!
I stood in awe of girls. I shared their naiveté and innocence. I felt like I belonged with them.

Hardly an hour of a great part of my life has passed without being distracted by what is manifestly feminine characteristic. The armor of masculinity which clanked and scraped and dug into me through long years held me from the fluid motion of full life. Prayer and meditation filled my life as Frances pushed at the gate. The woman was inside and hiding her was a ferocious struggle.

THOUGHT
FMD '75

In a prolonged siege of questions the gate suddenly opened and Frances was allowed to wander across my life in tentative style. For 3 years I led a dual life traveling discreetly, mainly to Boston, in full view as a woman but always returning home to Newburyport as a man.

After a life long search, instead of disappearing into a realm of anonymity where conflict might be minimized, the force in me was bursting its confines and I continued into my day in Newburyport now manifestly feminine.

I experienced a great calm, a lovely presence, an attainment of a superb freedom.

To be who one is means freedom.

The world was home again — no regrets, no apology — thrilled to be home at last.

Fran sent a letter to her family and friends (see Appendix) sharing the news of her embrace of her womanhood and inviting them to open their minds and hearts to her true self. Many did, some did not. Fran was elated with the response of the many who accepted her and she was accepting of those who did not. She hoped that understanding would come with time.

In 2001, Fran asked a member of our family to accept ownership of her work and, if possible, to attempt to promote and to preserve it. She hoped her life's work would be recognized as important by a wide and diverse audience. Having deep affection and respect for Fran, who was a close friend of our family from the early 1960s, we committed to trying our best to fulfill her wish.

Fran's work was in storage for a number of years until we could devote the time needed to sort and organize her papers, poems, sketches, and most importantly her slides. We began that process in 2018 and viewed thousands of slides of various subjects. We scanned nearly two thousand slides and from those chose the images for the book you now hold in your hands.

Fran Dalton profoundly touched and enriched our lives and the lives of countless others.

May you find in these pages the love, wisdom, and wit Fran so freely shared in her daily life and through her photography, poetry, and artwork.

<div style="text-align:center">Frank & Colleen Stiriti</div>

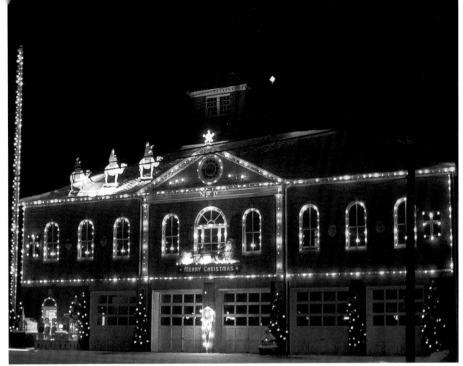

Firehouse Market Square Christmas 1964 (See Image Notes)

Excerpt from:
This Is What I Like About Newburyport:

Lemonade stands —

The tangle of bikes outside a busy 5 and 10 cent store —

Pigtails and dimples —

The call of geese in the night —

Swans in the pond —

The gentle east wind in summer —

Old square houses with old windows, bent chimneys, clothesline poles, warped picket fences, old trees —

Frills of iron on fences, lights, signs —

Apartments and studios hidden in ancient buildings —

Leaves on brick walks —

Stories about olden day incidents —

Weather-worn faces —

F. M. Dalton, 1966
Edited 2021, CHS

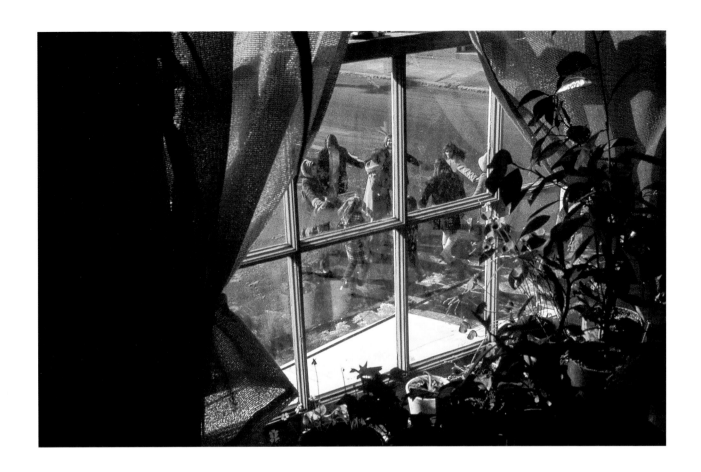

The Turn

A day, plunging toward the morose,
Teetering on the void of loneliness,
Turned.
The optimistic chatter,
Confident leapings and runnings
Of children
Came my way
And the winds of life-abounding
Swept through me.

F. M. Dalton
December 1972

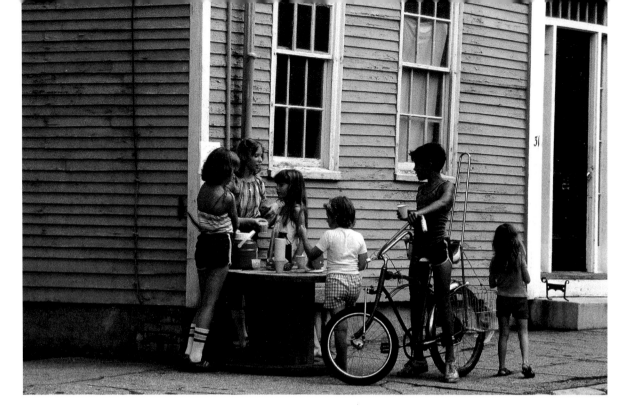

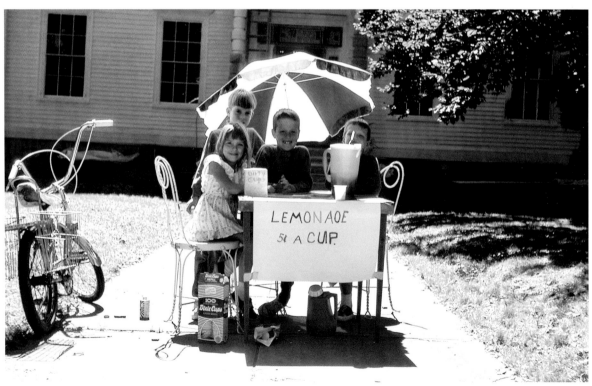

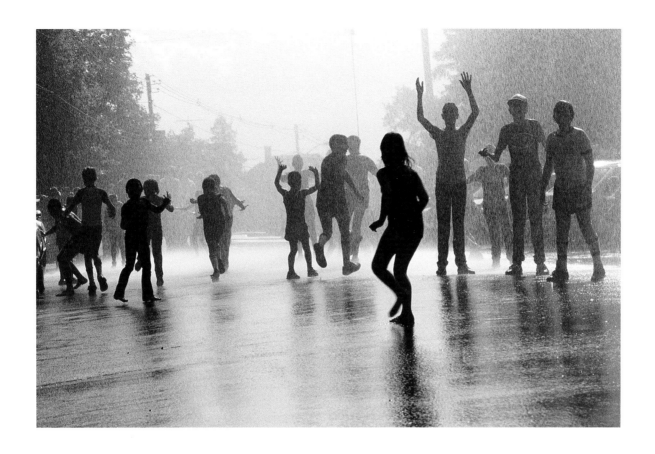

In childhood, one is one
And girls are boys
And boys are girls.
Laughter runs and leaps,
Where eyes could meet,
Arms could reach,
Feet could roam,
When one was one,
Girls were boys
Boys were girls;
The wind-swept, childhood way.

F. M. Dalton, April 1975
Edited 2021, CHS

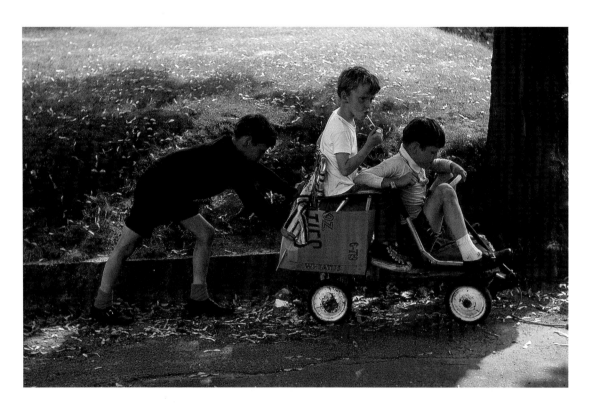

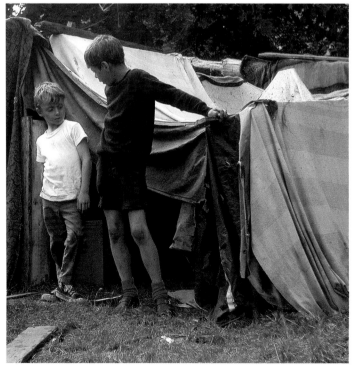

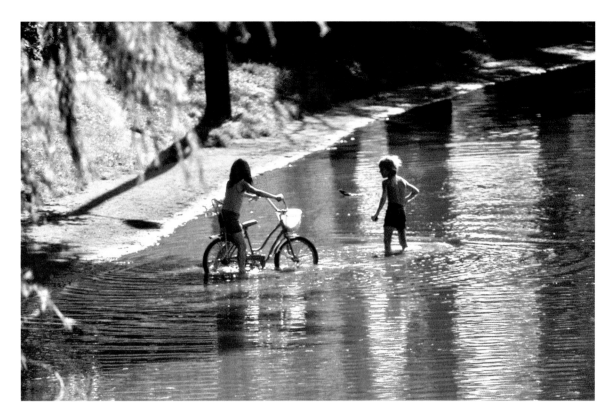

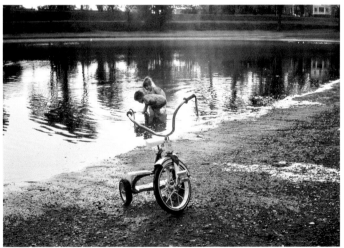

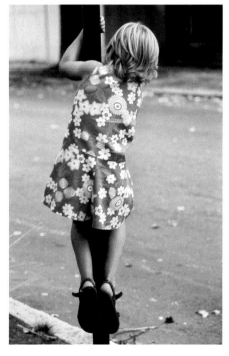

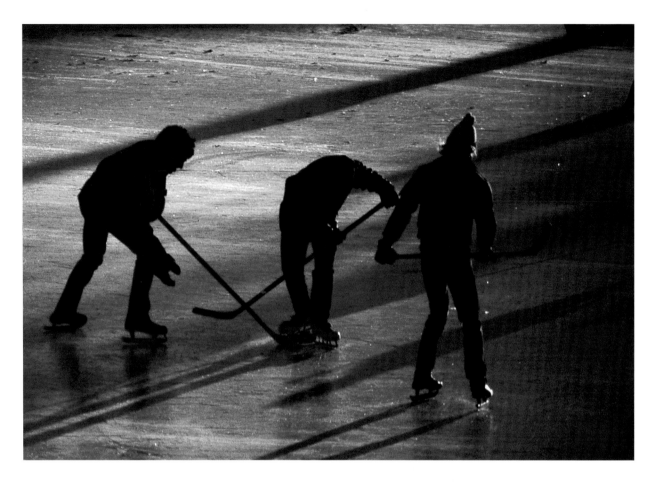

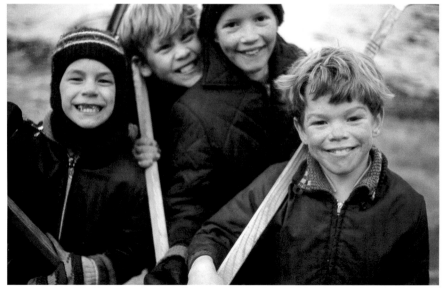

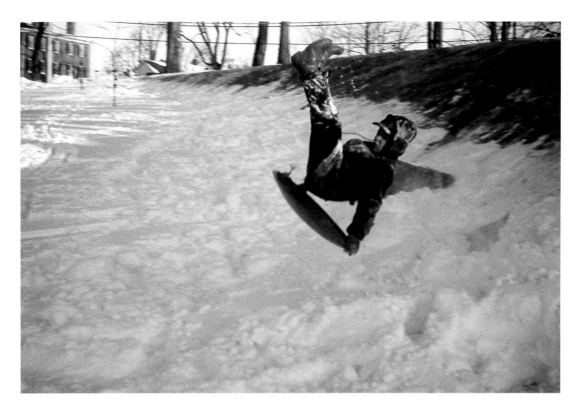

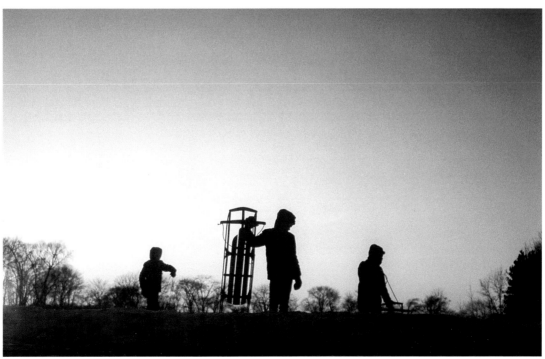

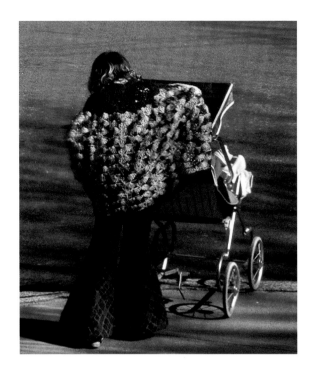
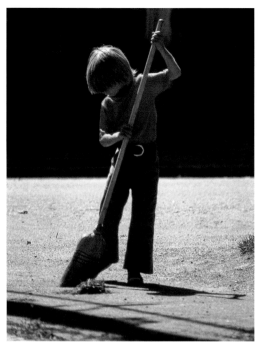
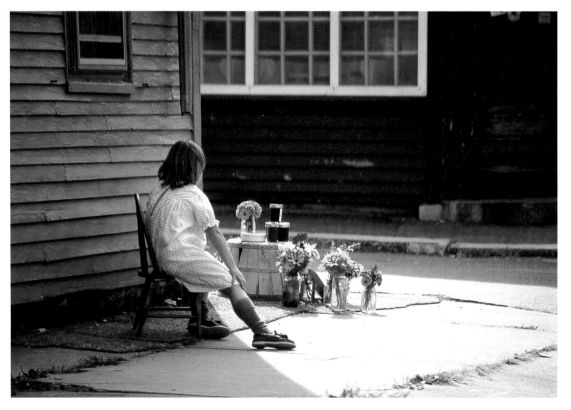

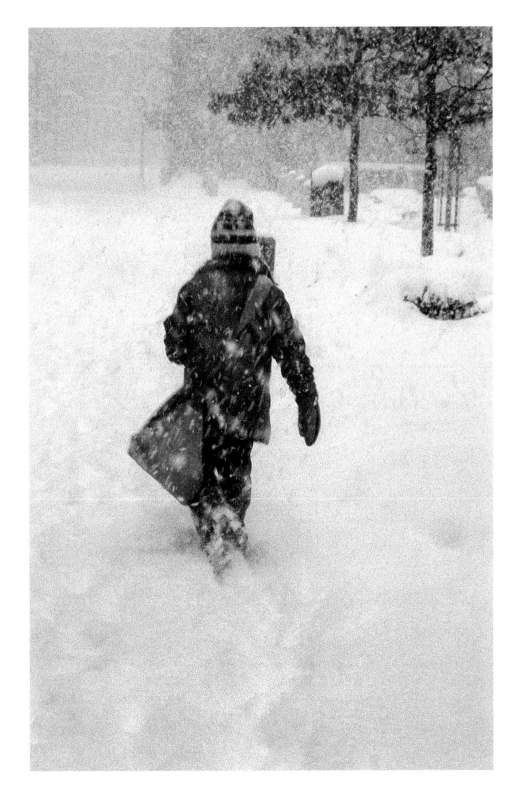

Nursing Home Paperboy

Boy, ----- paperboy
Do you know what you bring
To those
Who know, without even-a-glance,
It's your hand on the door,
Your gait down the hall ?
Your supple form,
Alert eyes,
Flung hair ?
Winged spirit of their days,
You bring twenty-or-so pages
 of print for fifteen cents,
And leave your stardust
 everywhere !

 F. M. Dalton
 1972

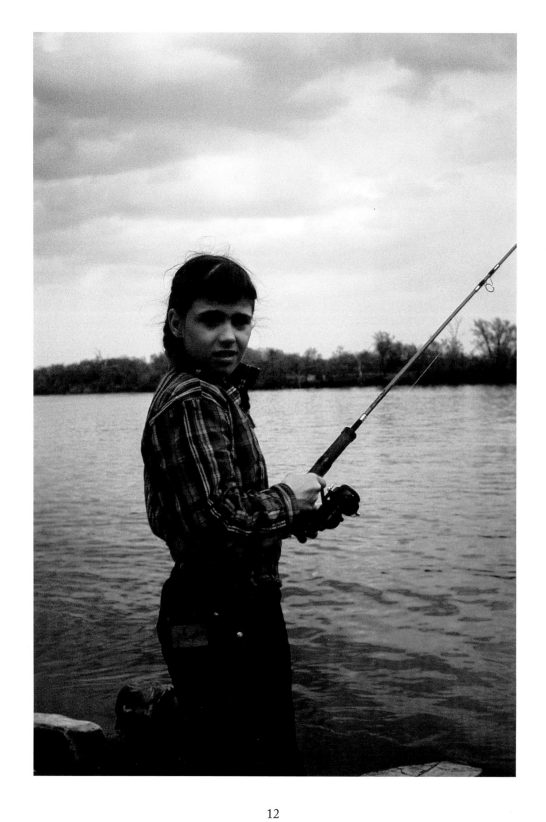

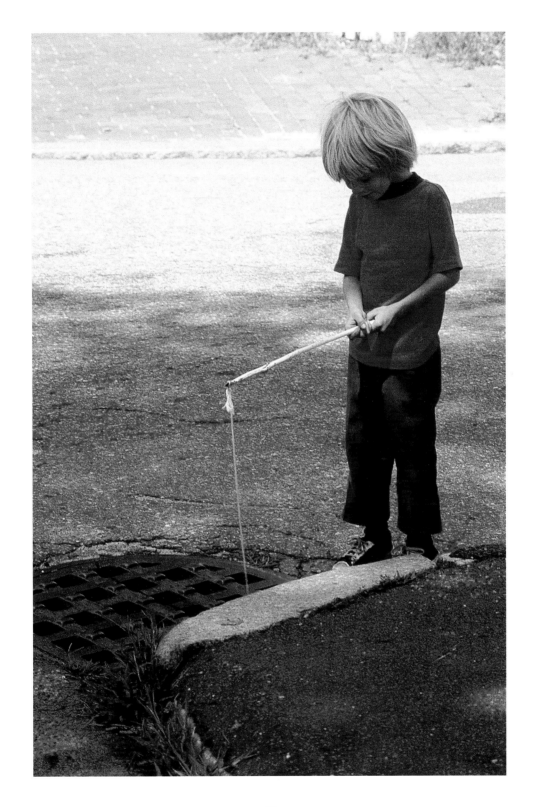

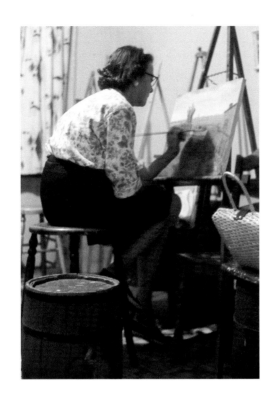

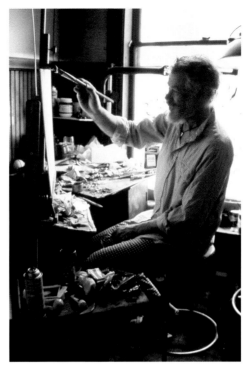

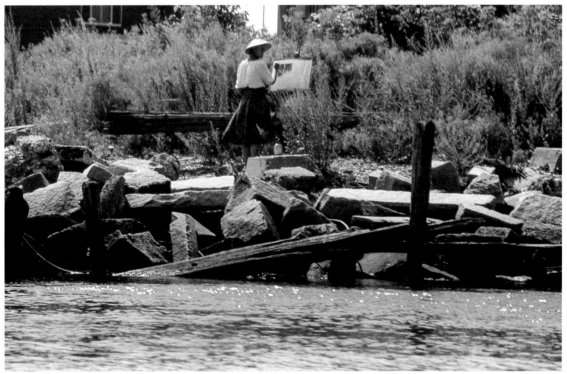

MUSIC LESSON

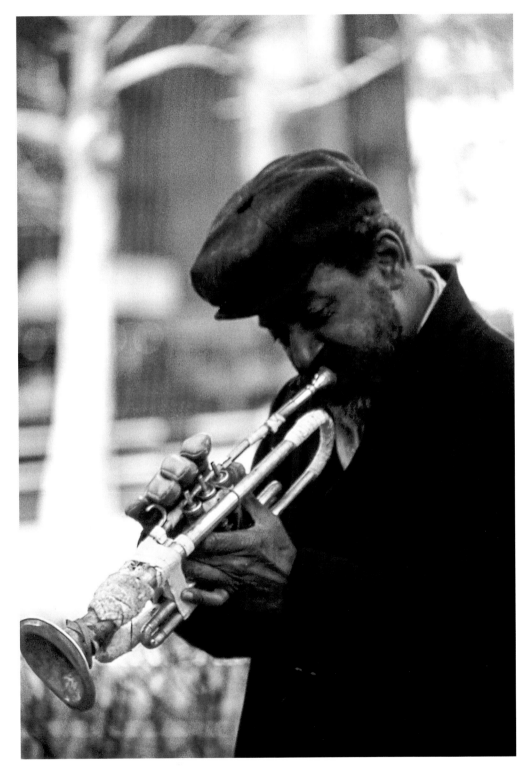

Street Performer
New York City

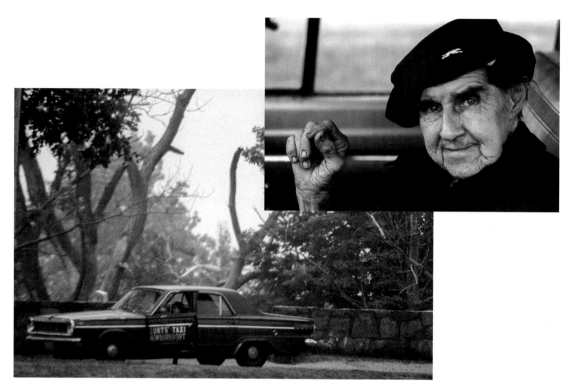

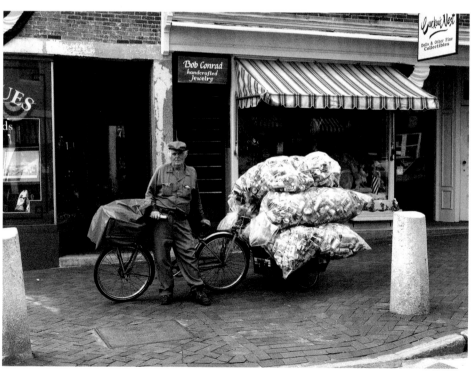

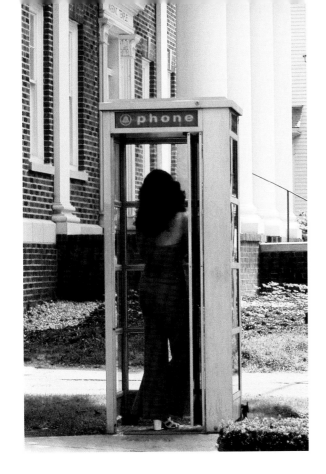

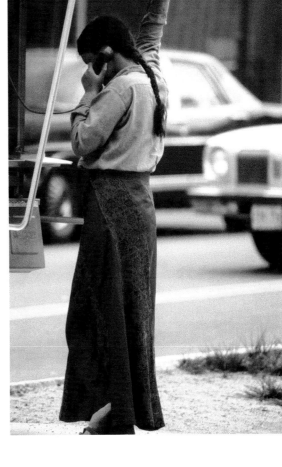

WHERE, WHEN, HOW ???

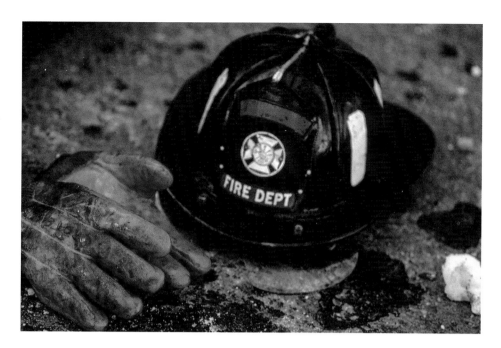

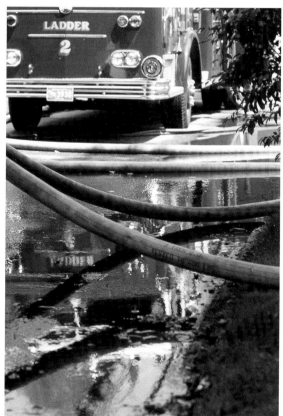

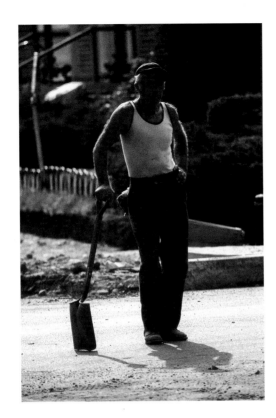
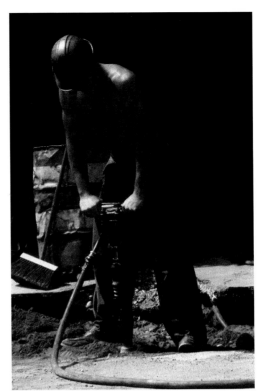
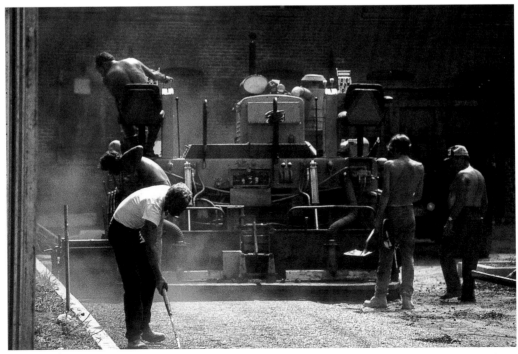

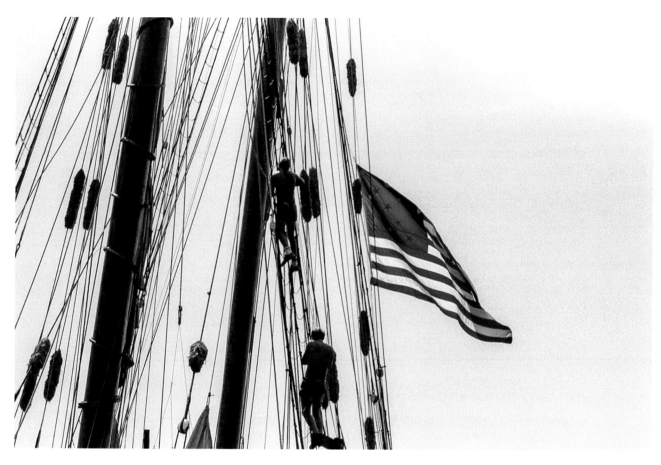

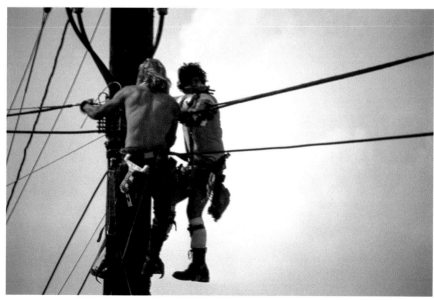

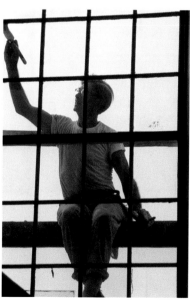

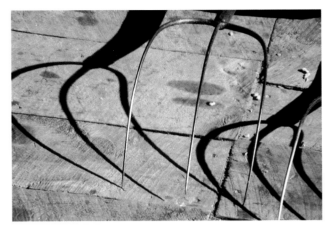
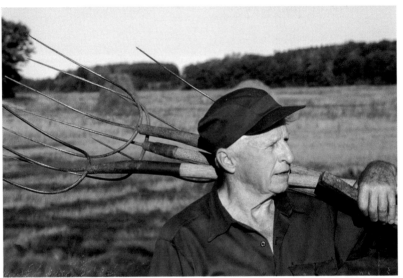
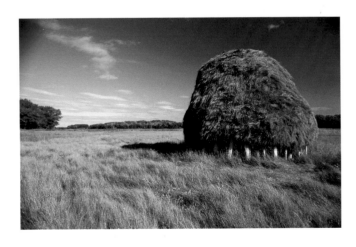

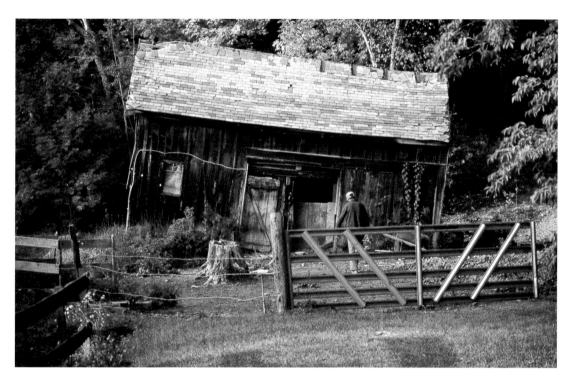

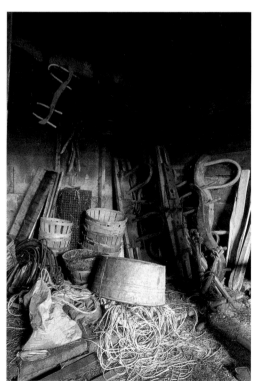

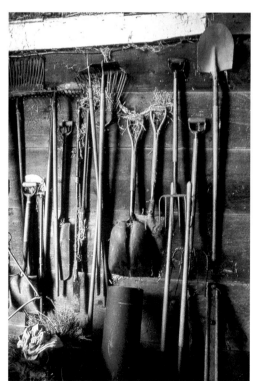

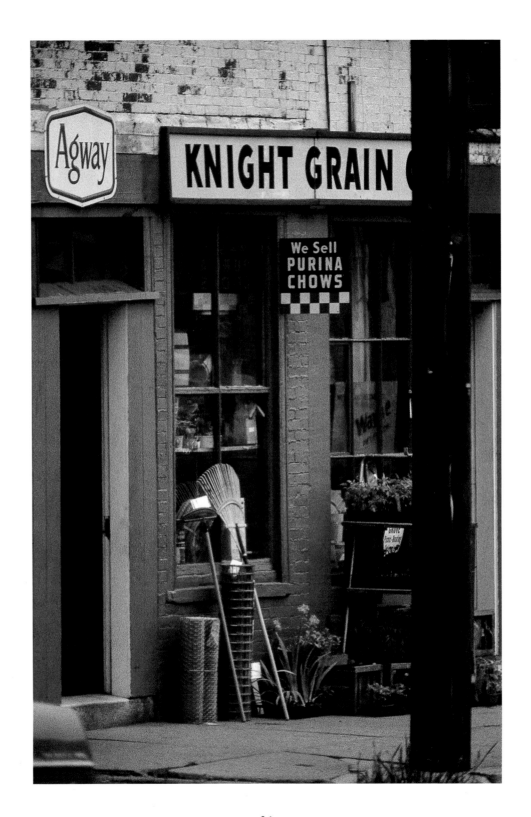

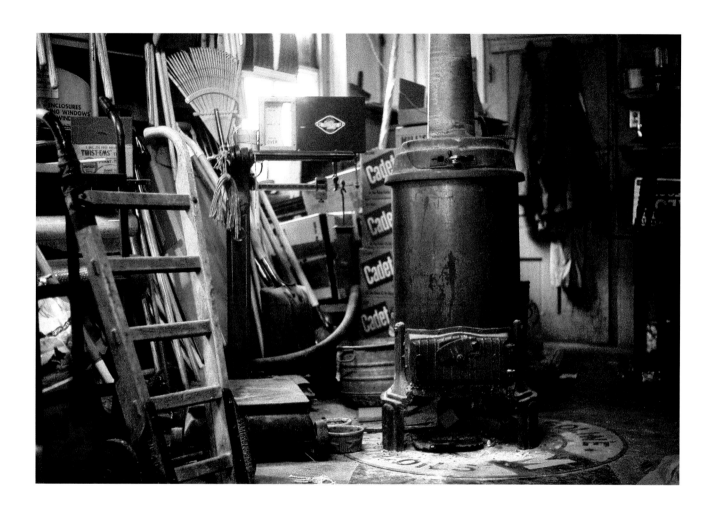

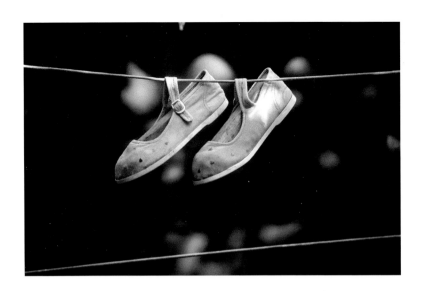

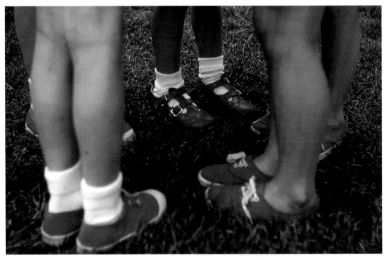

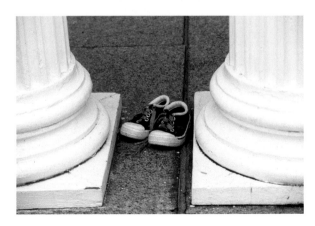

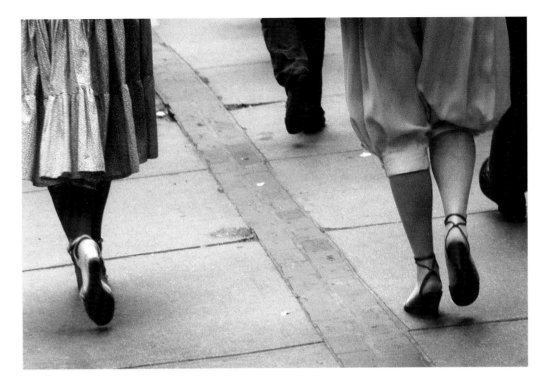

Boston, MA

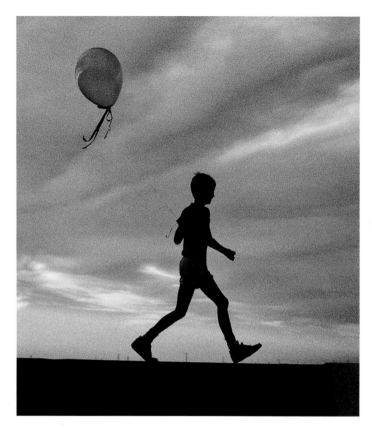

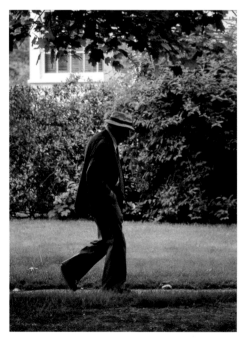

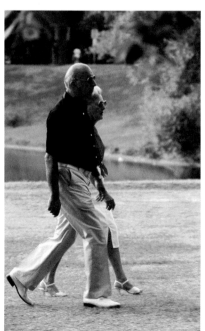

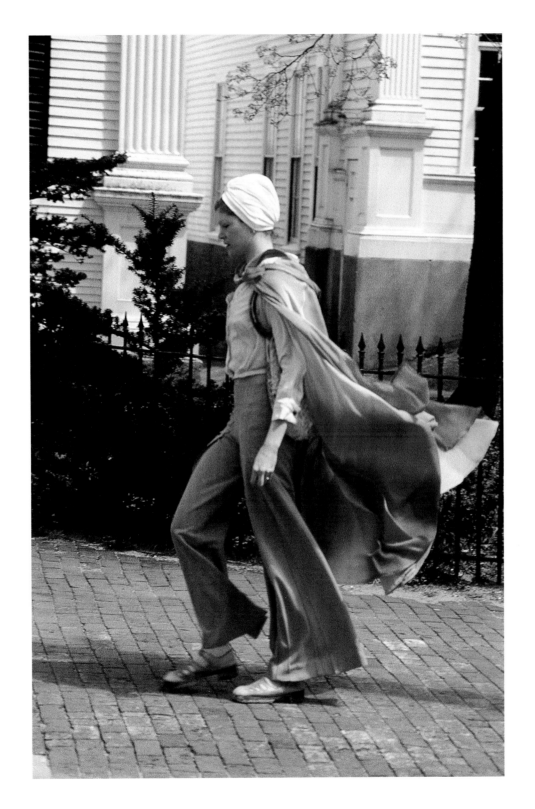

CHARLIE STIMPSON
FALL '65
FMD

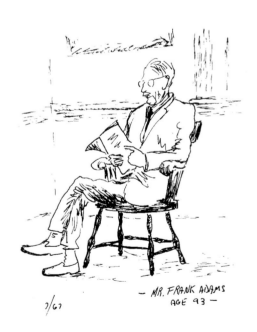

7/67

— MR. FRANK ADAMS
AGE 93 —

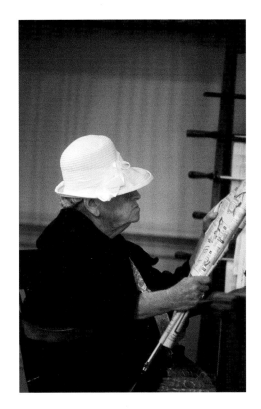

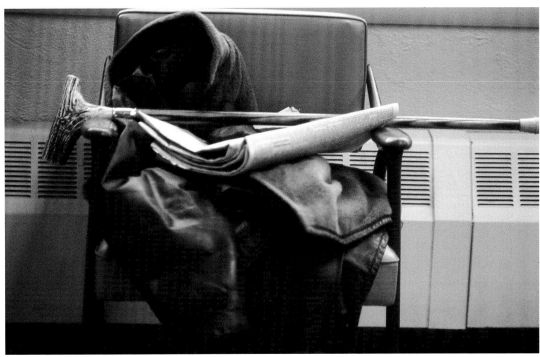

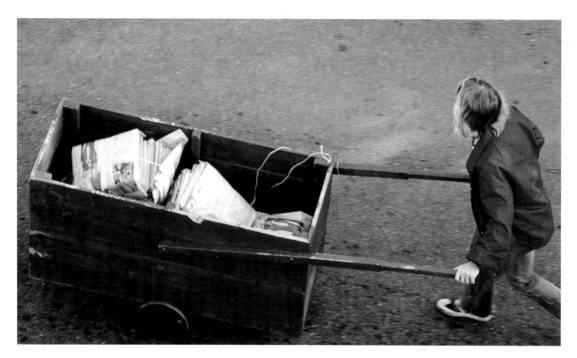

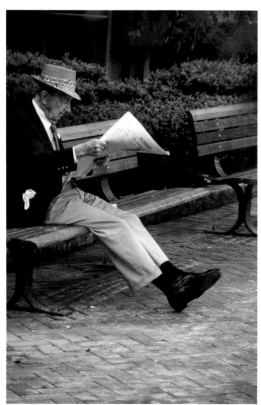

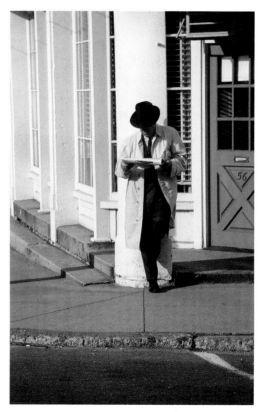

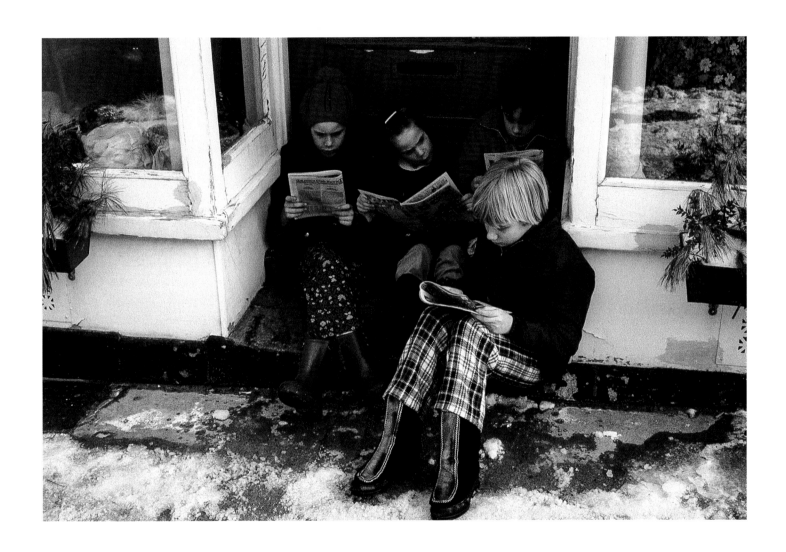

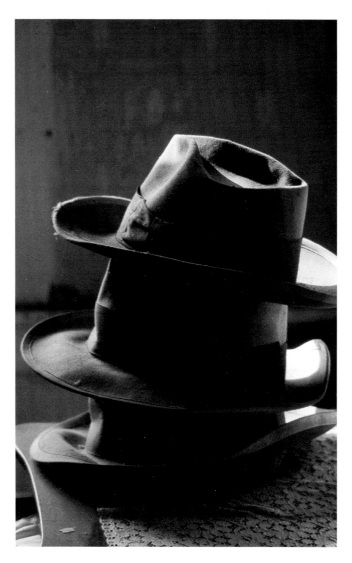

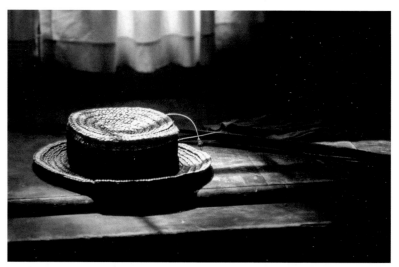

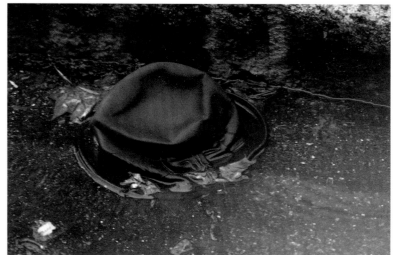

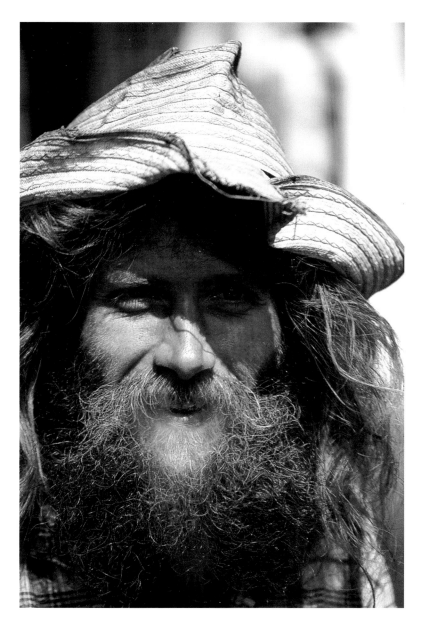

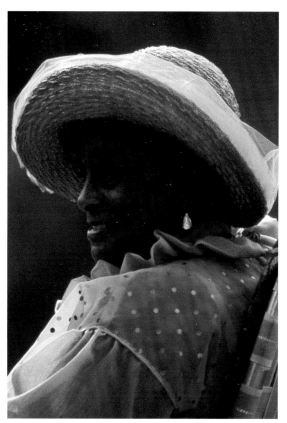

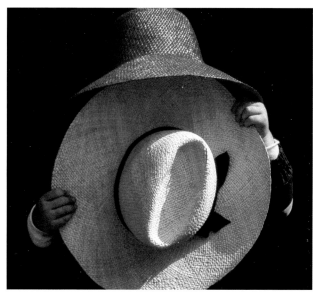

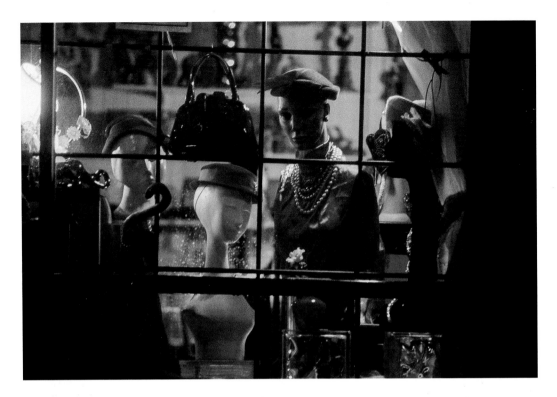

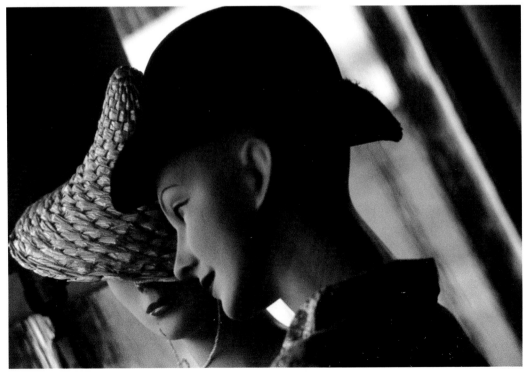

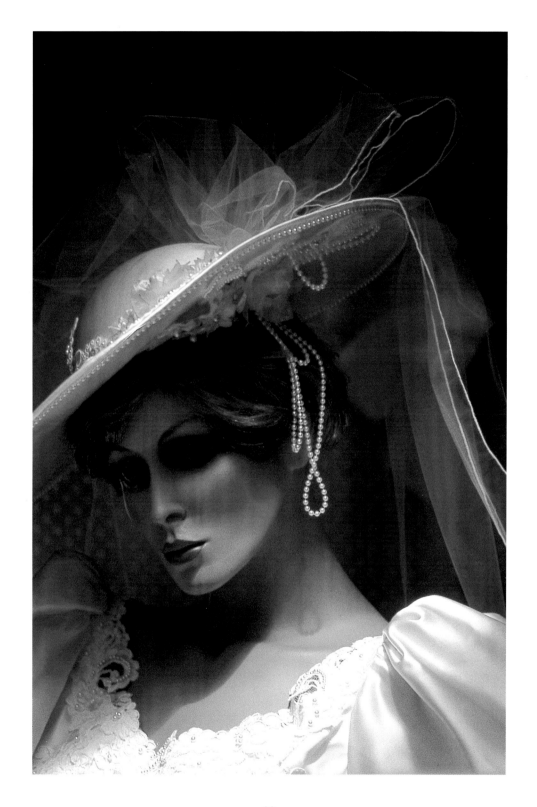

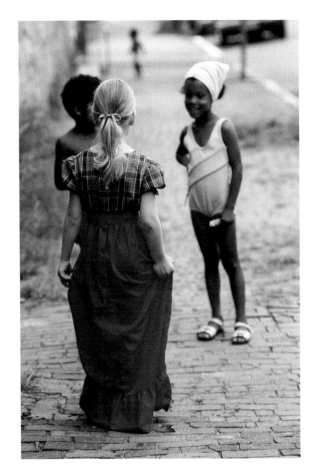

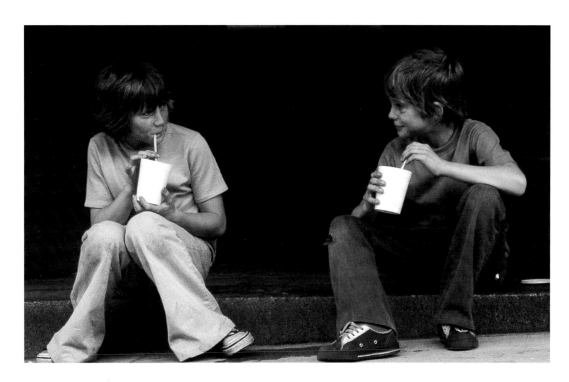

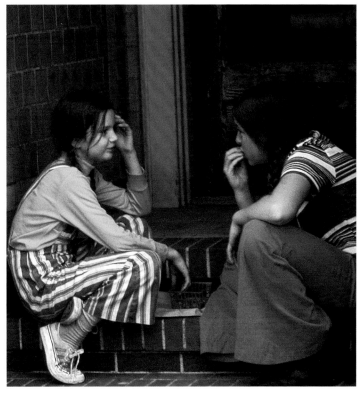

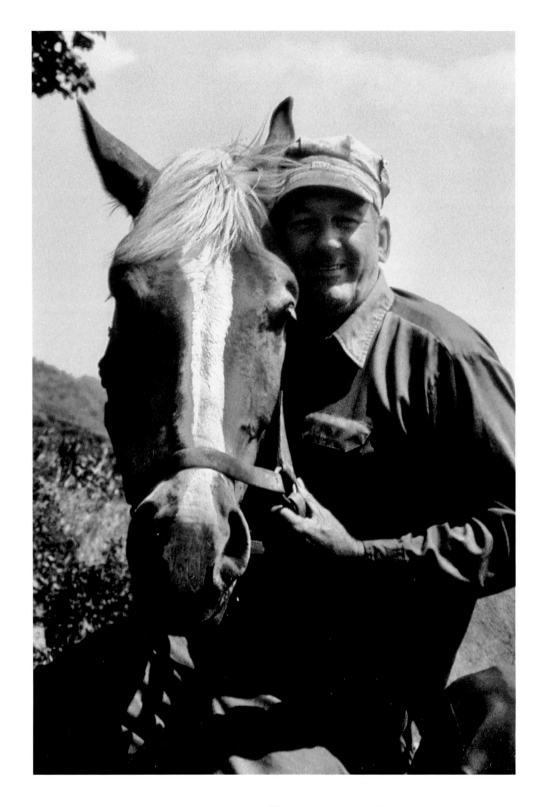

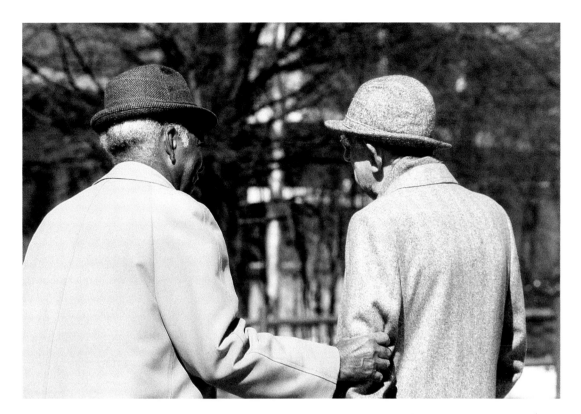

I'LL SEE YOU
THROUGH —

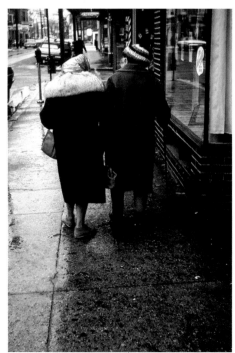

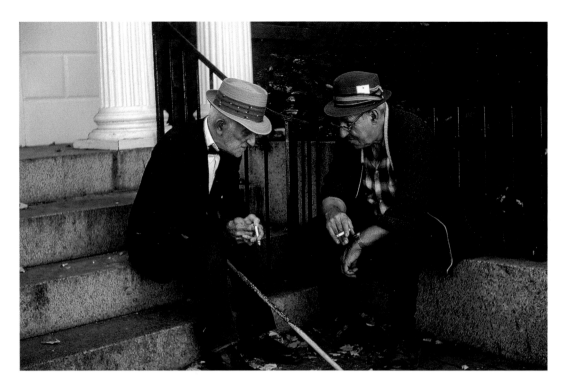

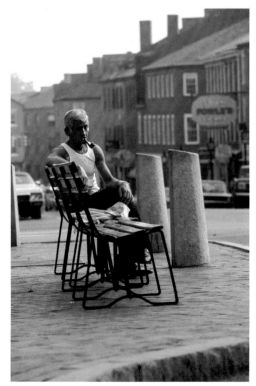

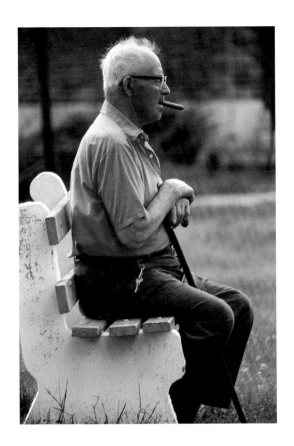

Let's not measure life today;
Let us just plunge ahead, each one;
Our destiny is intact, friend;
Let's face the wind, embrace the sun.

F. M. Dalton
Edited 2021, CHS

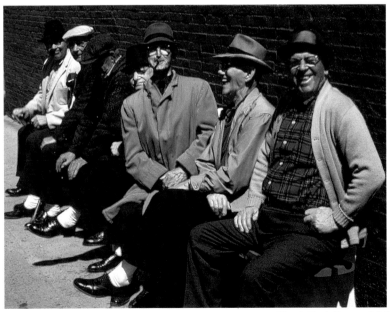

North End, Boston, MA

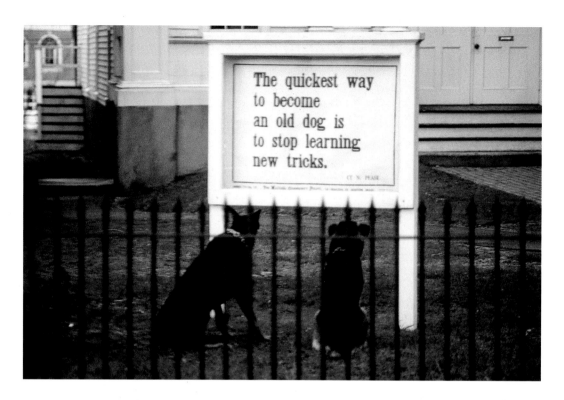

The quickest way
to become
an old dog is
to stop learning
new tricks.

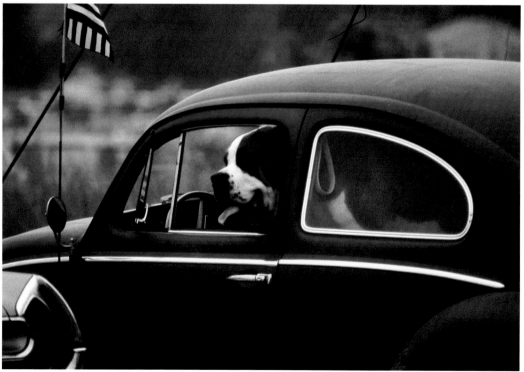

"Abe"

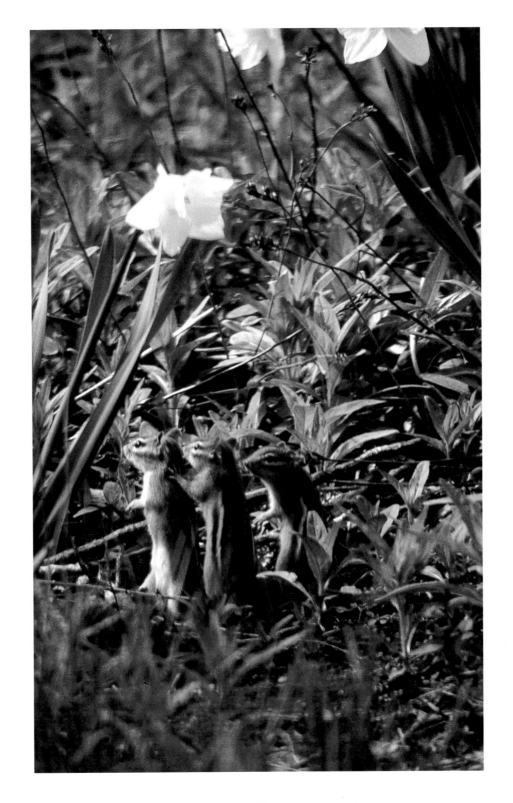

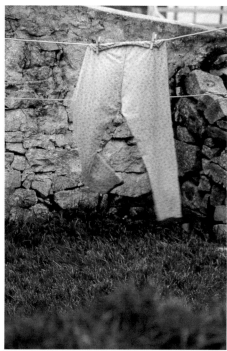

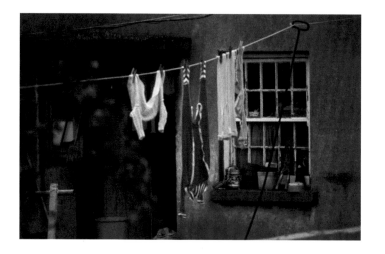

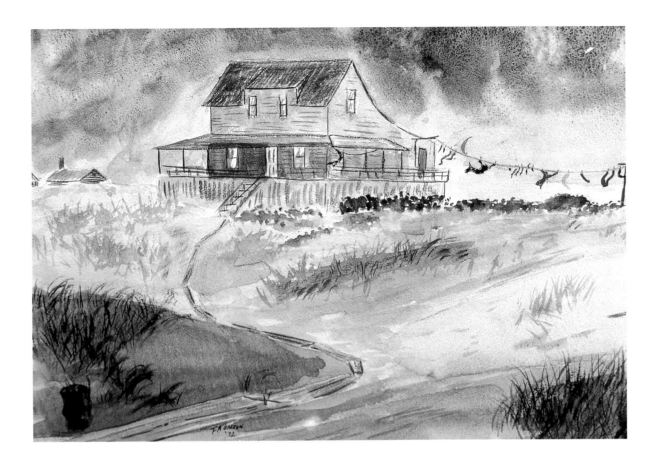

The House Mouse

"Why not live in this old house?"
Said a tiny, gray, lonesome mouse
As wintery winds ruffled his fur
And shivers, all over, had begun to occur.

"Under the porch I'll wait and wait
'Til the door is left open and I'll go straight
Through as quick as a wink
And hide in the cupboard under the sink.

You see, I need water and a bite to eat;
Not much else — oh, a little heat
Would serve well to round it all out,
And a nice, old kitchen to roam about."

Soon came his chance and in he sped,
Right to the sink, as he said,
Dashed the swift mouse, and hidden away
In there, somewhere, he roams today.

F. M. Dalton
December 1971

49

The Digs

(See Image Notes)

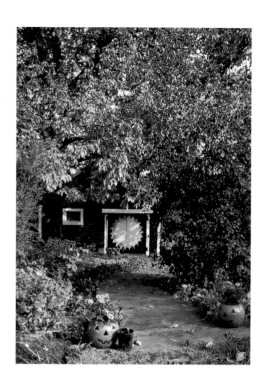

The Viking
Luigi
and
his Raven
Charlie.
Sculpted by Fran c. 1998
from Styrofoam scraps.

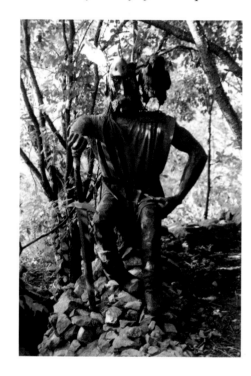

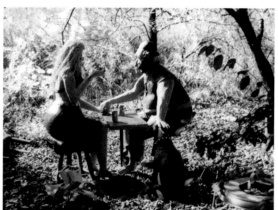

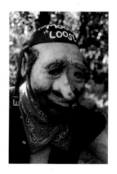

Moose, Josie,
Brutus

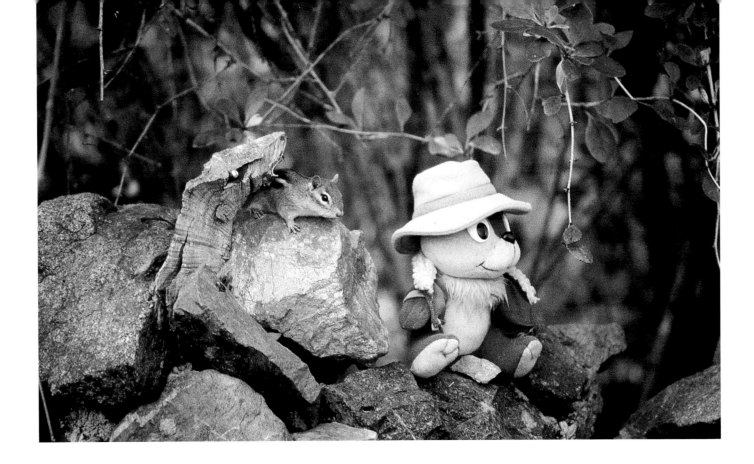

I'm a little chipmunk
Atop a little hill.
I await my supper
When I can eat my fill.

Tonight it's seeds and grapes
All served at 4 o'clock.
Old Phranny put it out
On top of yonder rock.

O, I love the sunflowers!
Their seeds are simply swell.
Oops! I gotta go now, friend,
I hear the dinner bell!

F. M. Dalton
August 2002

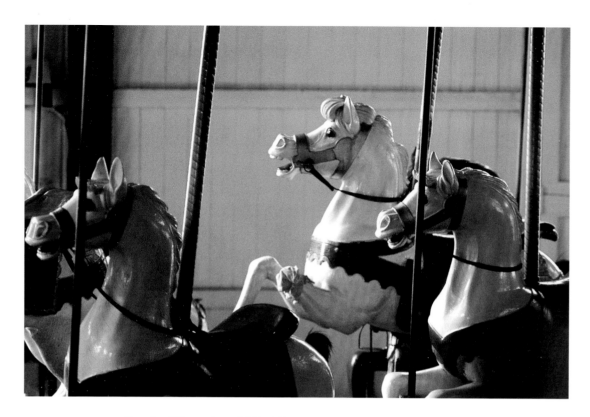

In the Temple of Childhood Merriment *(See Image Notes)*

We come to a place filled with excitement … a land of merriment.
Inside are the brilliant animals, poised in stillness.

I run among them, find a horse standing high above me, climb, on real stirrups,
up to its back and reaching, feel its neck, the rippling muscles, the slender ears …
I am rising, rising, rising. My horse and I are one.
Its spiral, brass pole is smooth and summer-warm; its leathery reins are in my ---- my hands …
A strong motion, a going away begins in the great, vaulted place.

We sweep through, out, into the wondrous realm of adventure!

My horse sweeps on and on and on —— Then, having raced among the very stars, the great
column of animals slows, gliding softly to stillness. I loose the reins, climb down my sinewy
horse, step down, cross the red line on the floor … move on, move out,
filled with the wonders of the shadowy domain of the Merry-go-Round.

<div align="right">

F. M. Dalton, 1975
Edited 2021, CHS

</div>

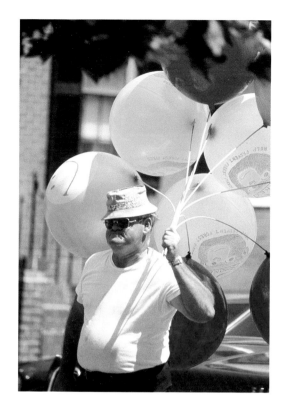

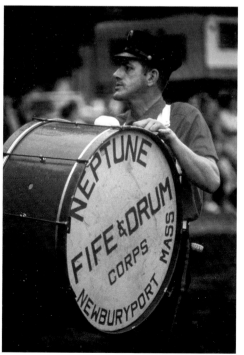

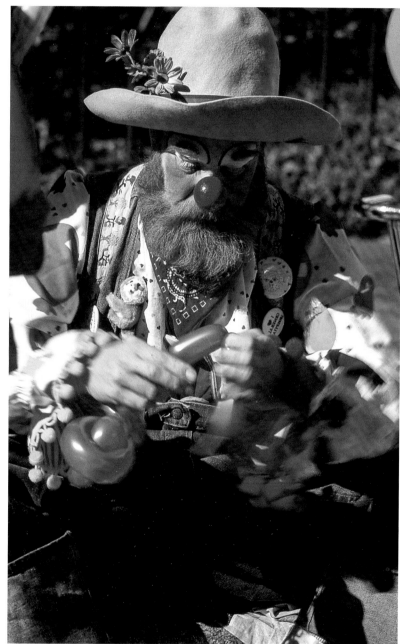

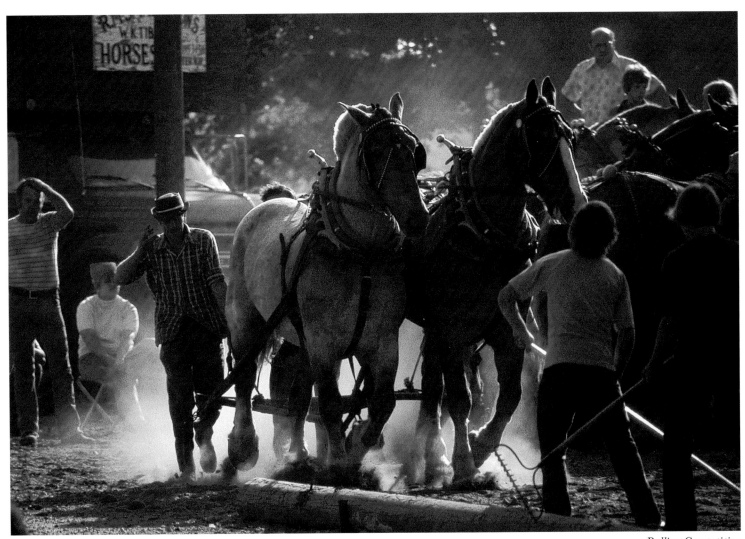

Pulling Competition

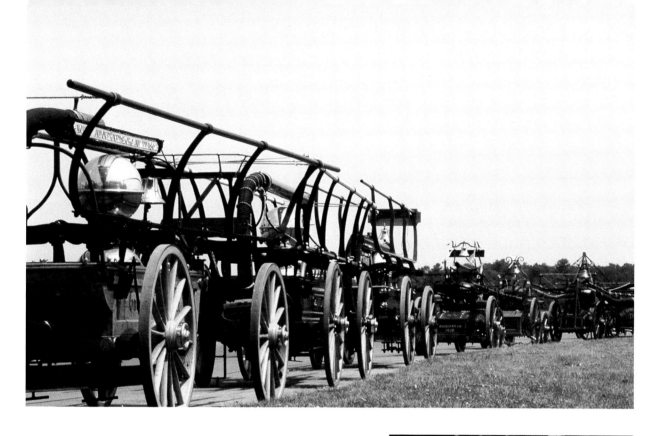

Firemen's Muster

Auction on the Green, Newbury, MA

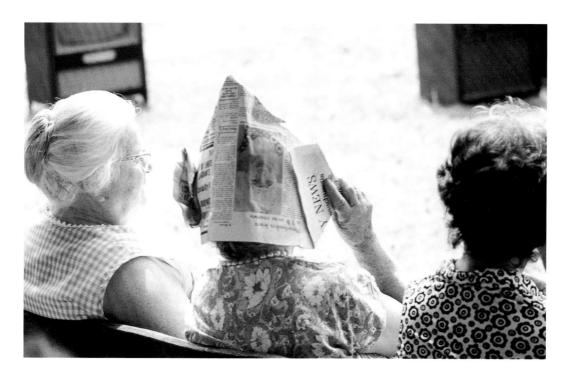

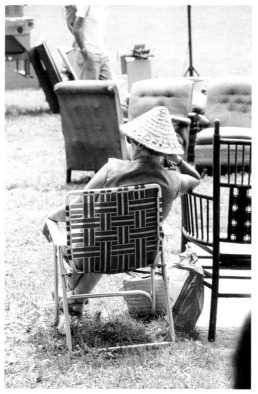

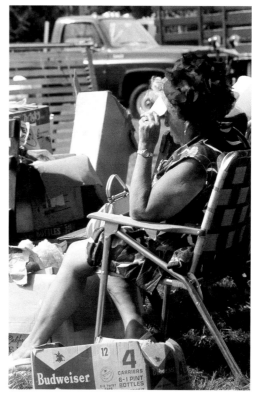

Old Faithful

There's a horse outside my door
Who's dressed up as a bike.
We roam the night together,
We do as we like.
No matter what the chore
You see, he's just congenial —
Always willing, faithful,
Be it mighty or menial.

F. M. Dalton
January 1972

OLD TRAVELLING MAN FMD 75

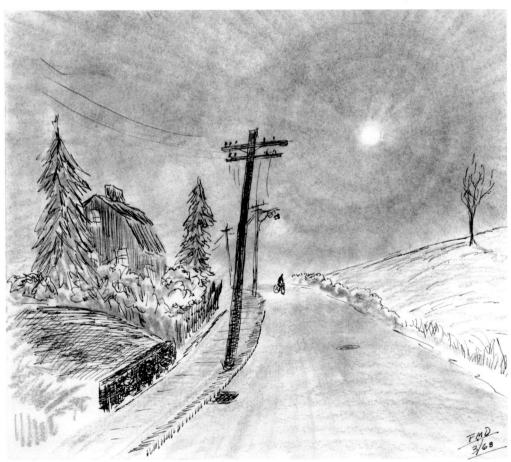

FMD.
3/68

58

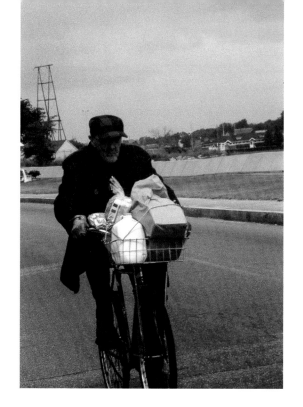

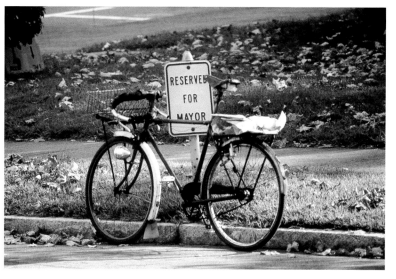

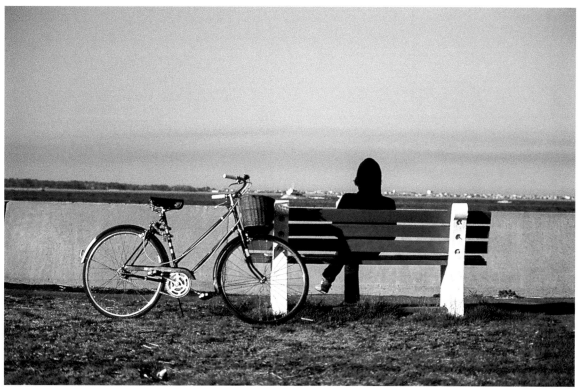

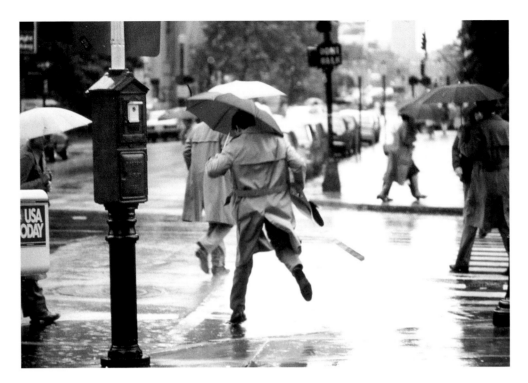

Spring Umbrellas

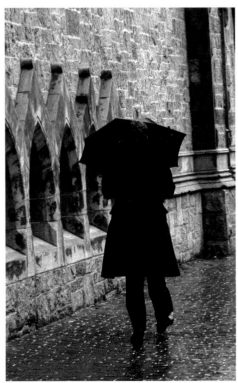

Summer Flowers

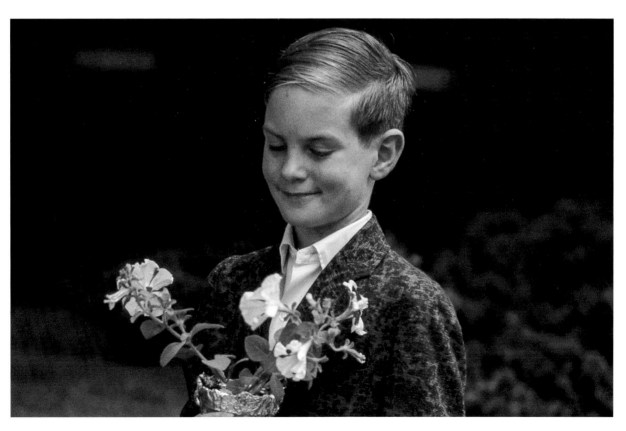

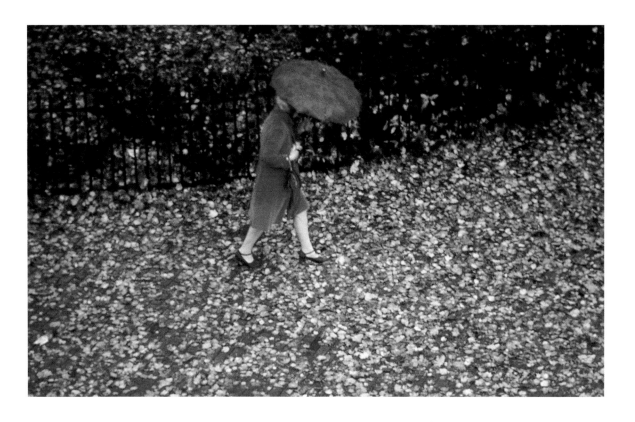

Autumn Colors

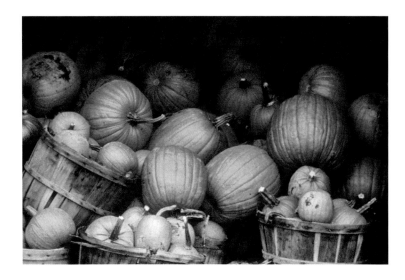

HOW WOULD YOU LIKE TO BE
MY JACK-O-LANTERN?

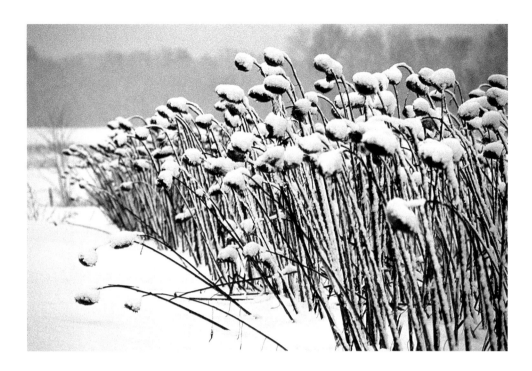

Winter Quiet

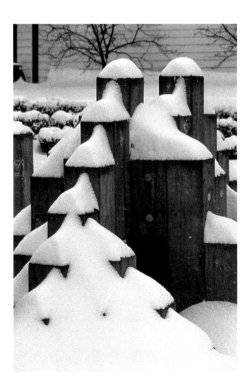

It Snows

Gray, wet pilings by the riverside,
Noble, old steeples,
Curled, dry leaves
Become theatrical these nights.
Now is the stage of winter, carefully set;
The house of life is hushed
And ever-so, ever-so softly
It snows.

F. M. Dalton
January 1974

63

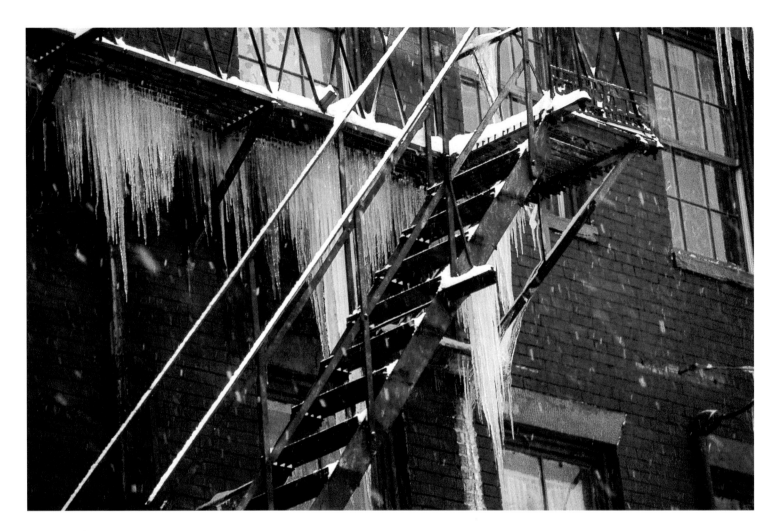

Bereft

The night is cold,
No words of cheer,
No friends of old
To still the fear
 of loneliness
 of emptiness
 of lightlessness
 of night, so cold

 F. M. Dalton
 December 1967

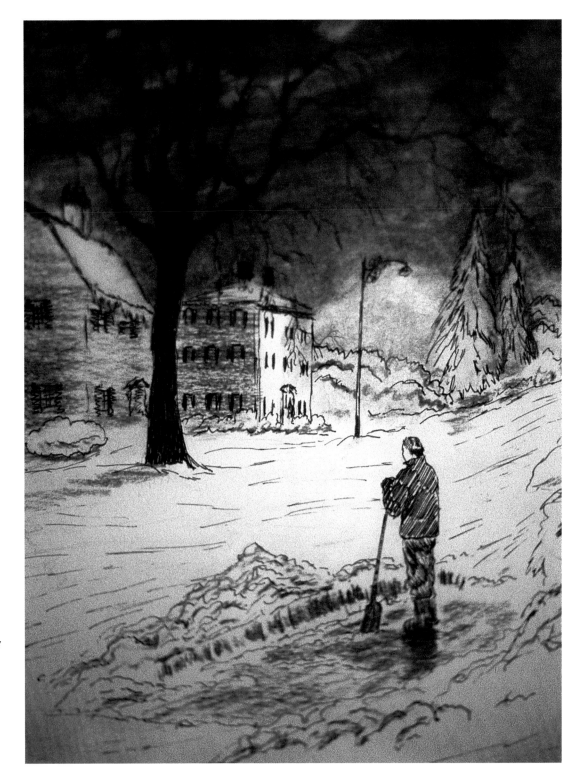

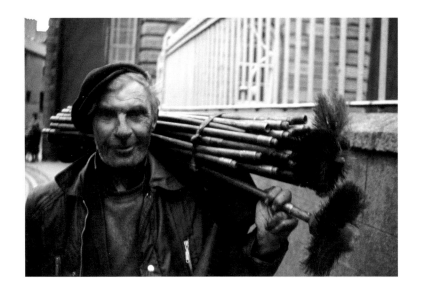

My Irish

If my voice could resound over mountains;
If I were a noble king
Or a valiant guardian of the meek;
If my sinews were as supple steel
And I could leap aloft as the albatross,
I would sing, heart swollen full,
Of Ireland, her children,
For I have known them,
Hearts so dear
And I yearn to sing of them.

F. M. Dalton
March 1972

Ireland

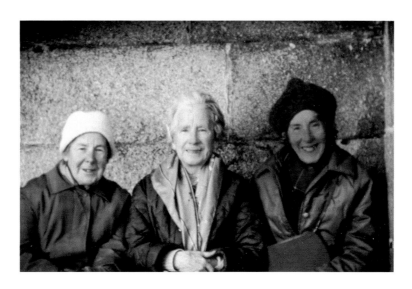

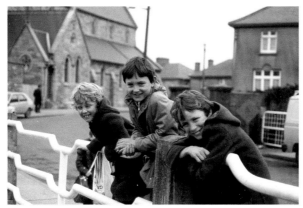

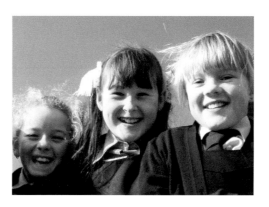

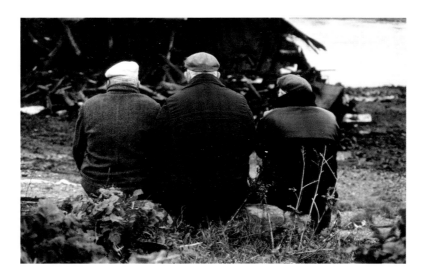

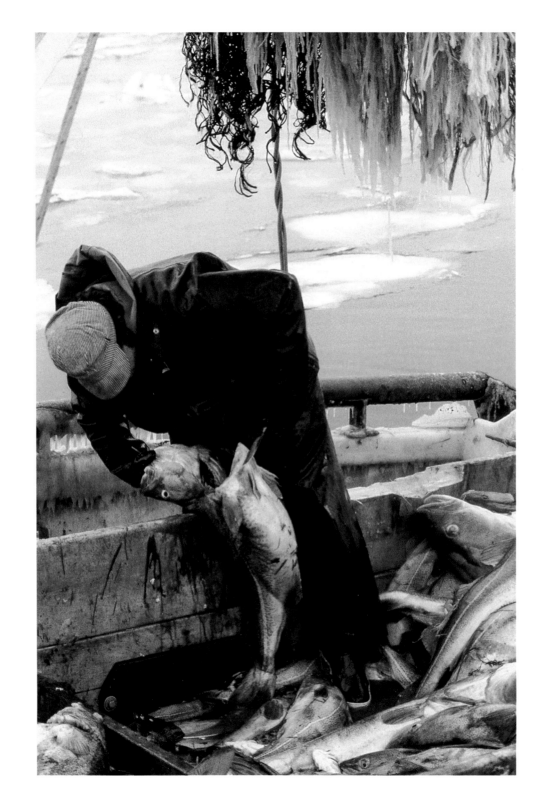

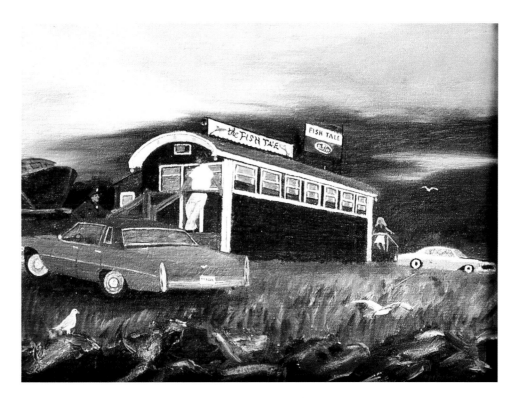

Salisbury, MA

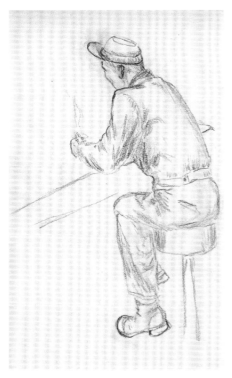

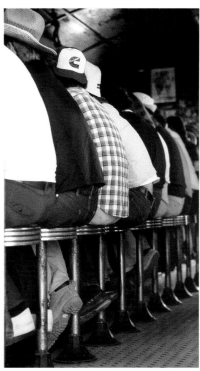

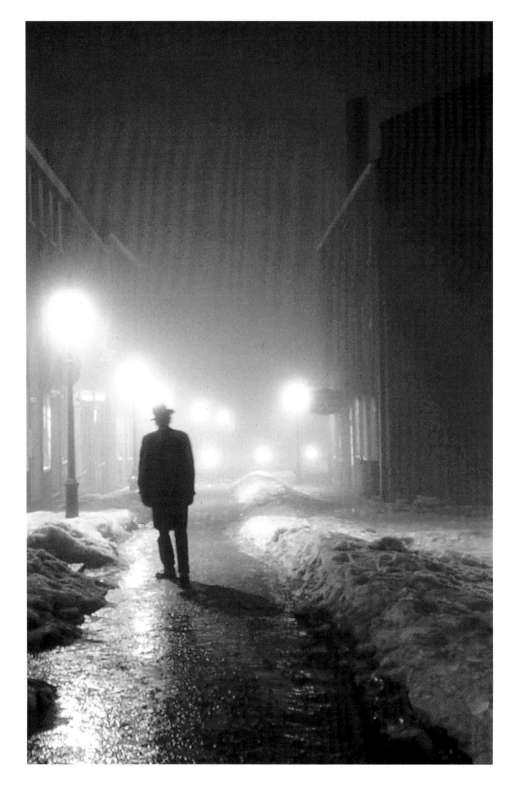

"The Ghost of Inn Street"

The Fog

The land reclines in fog
As I glance down the way.
There, one treds unseen
Before the coming day

So, on with coat and pack,
On to the misty hollow;
I'll seek what lies therein
And hope about tomorrow.

Yes, my hours will be livened
By the search for the sight
Of cherished home and hearth
Through the fog in the night.

F. M. Dalton
1971

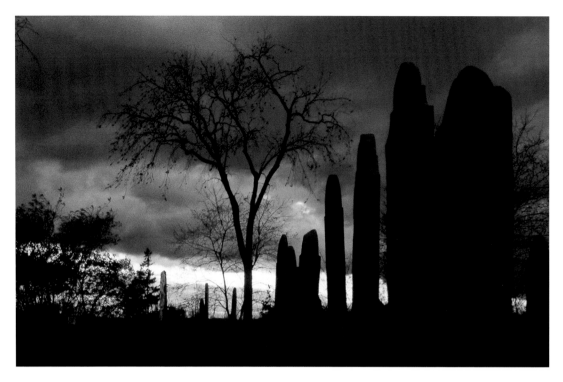

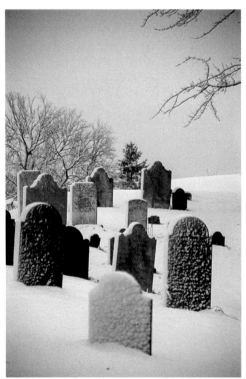

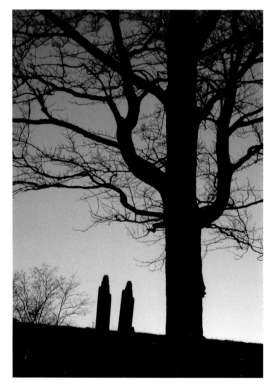

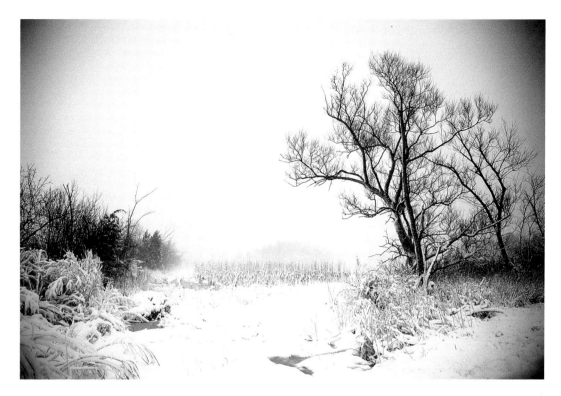

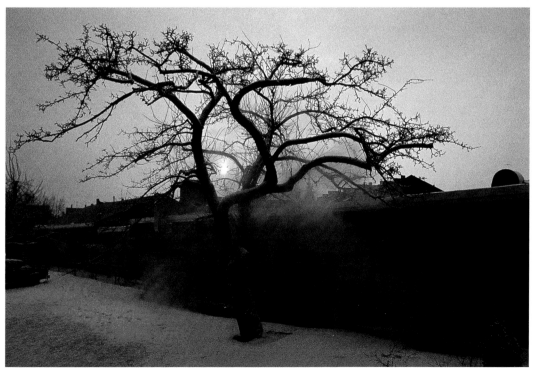

An Ode upon Duncan's Homecoming *(See Image Notes)*

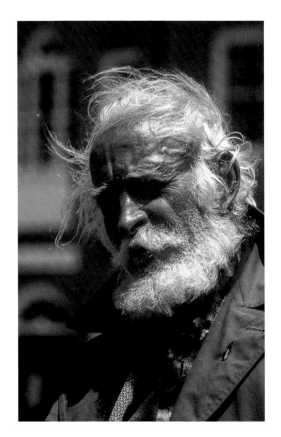

Six crows flew north upon the hour
As we trod back to town
From the ancient burying hill
Where we put Duncan down.

"Fly ye, above our little spot,
We folkies in the dell
Come o'er the hill to tip a hat
At Duncan's wee farewell

Yea, Duncan, little, lovely girls
And mighty, pond'rous men
Whispered soft things about you there
And became, more, your kin

And witnessed how, right along, Dunc,
Amid the dark and cold,
Inside your raggy tatters
Was, yea, soft, gleaming gold.

How we all wished, as you, my friend
For the long pain to flee
But not one can be knowing
When a man will go free.

Ah! Farewell, there in the dell, Dunc
Of Newburyport town
And merrily we'll be going
From putting Duncan down!"

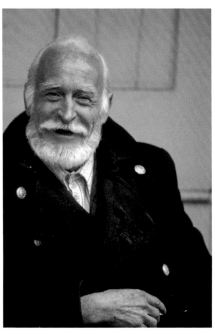

(Duncan)
"Say, now, walk on, ye merry folk—
Put a cock to your hats
For we, my dearest friends, of old
Are, we all, cool, cool cats!"

F. M. Dalton
October 1, 1980
Edited 2021, CHS

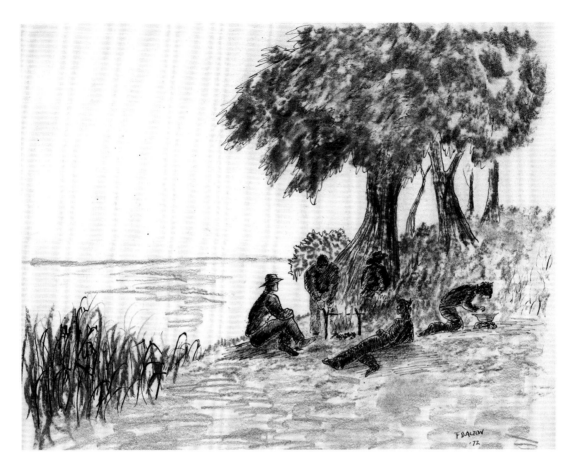

Suddenly, a moment
When life is running sweet;
Floating in contentment
A reverie complete.

Work gained accomplishment,
Good food renewed one's strength;
Crickets on a soft night;
Reclined in dark, full-length.

All one's friends are present;
Memories crowd around;
The order of the universe
Spreads upon my ground.

F. M. Dalton

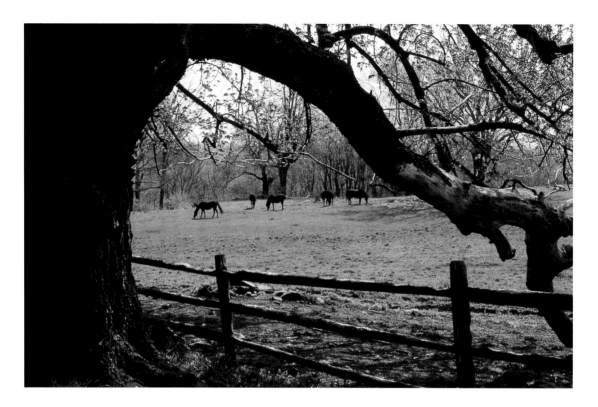

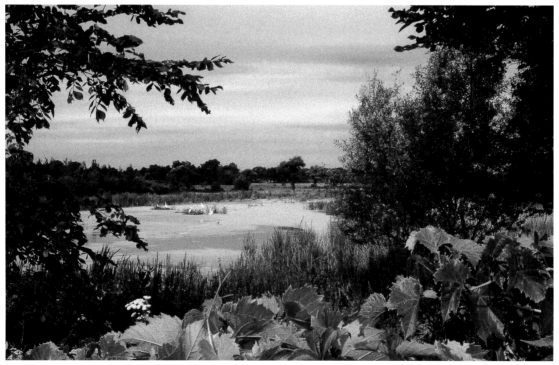

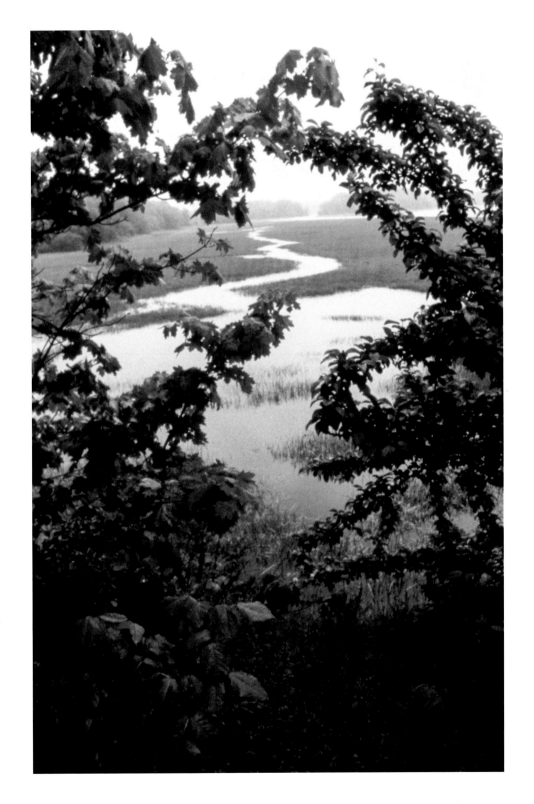

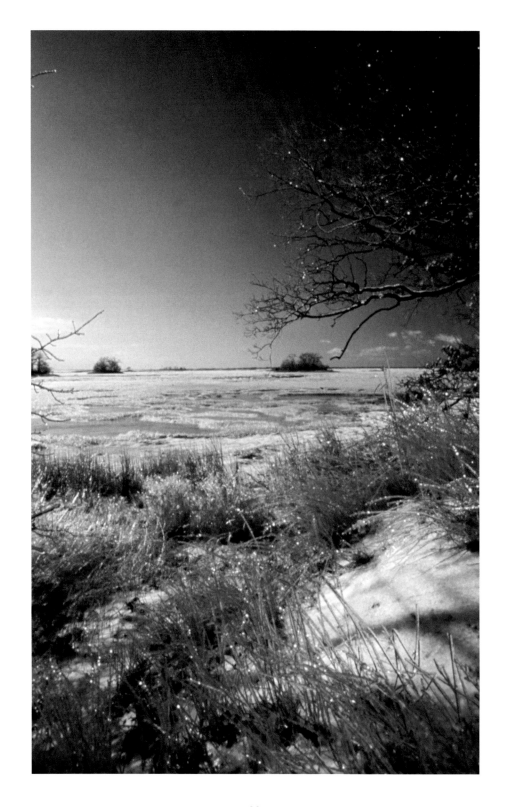

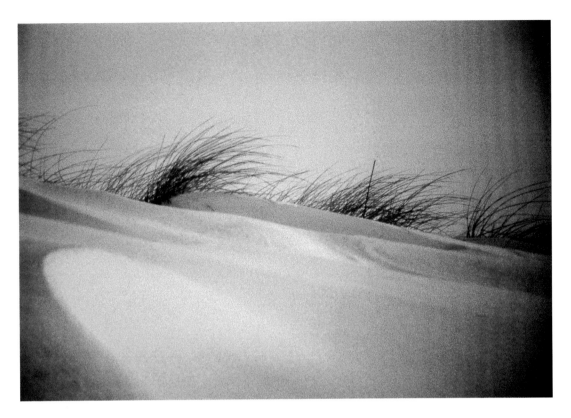

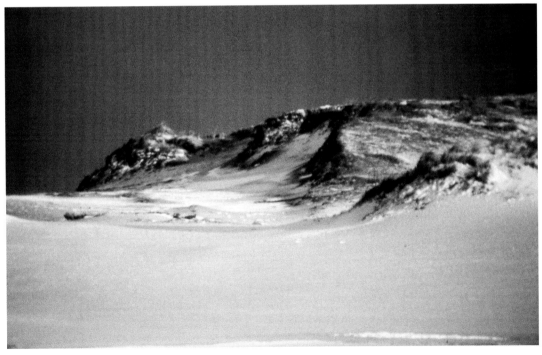

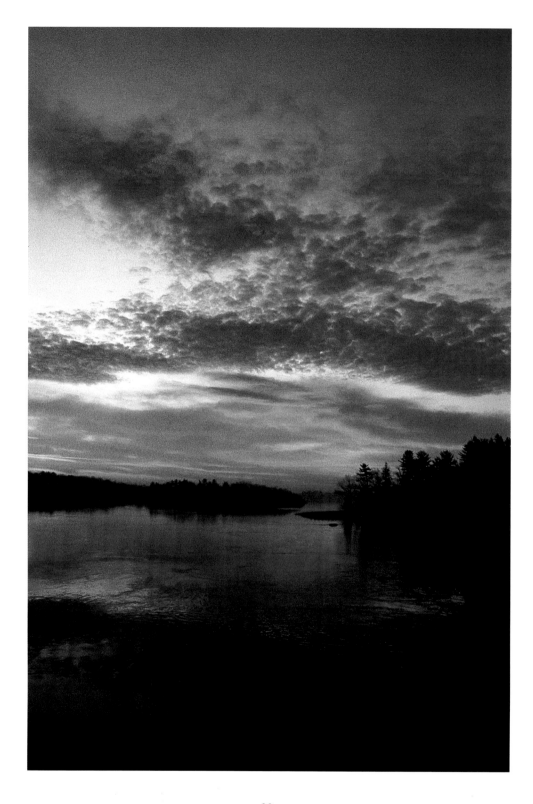

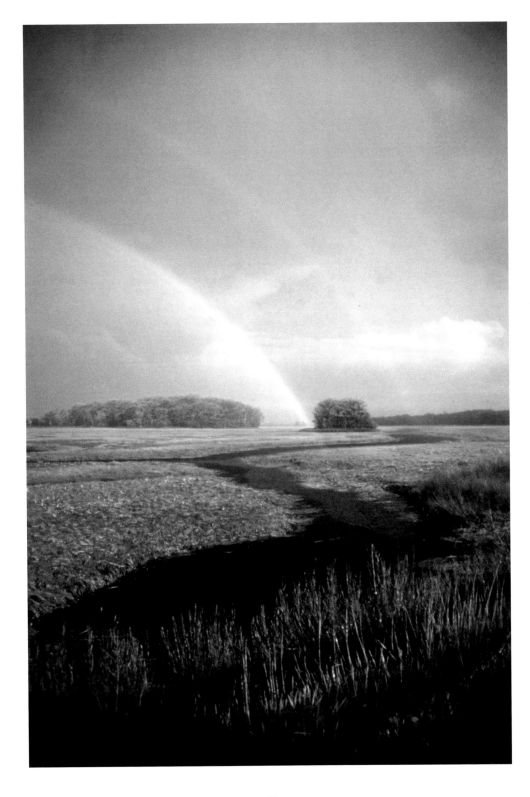

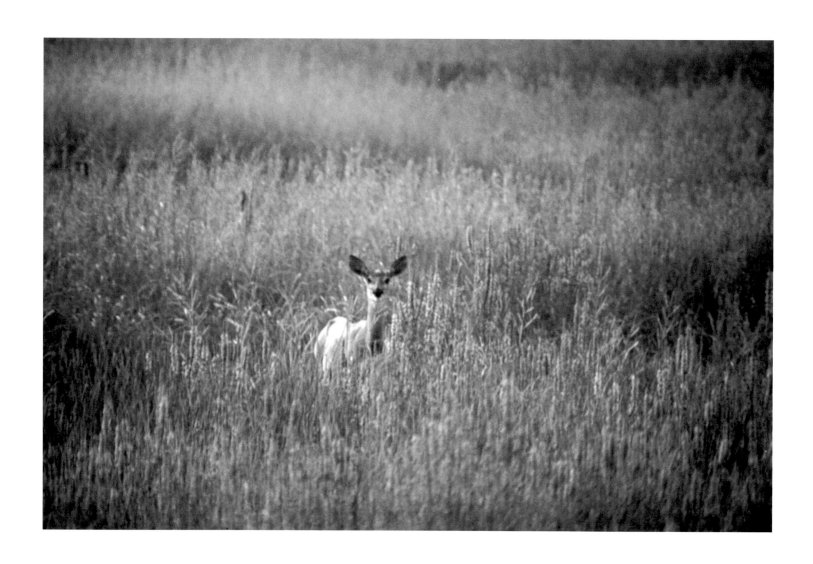

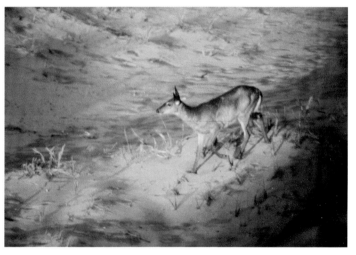

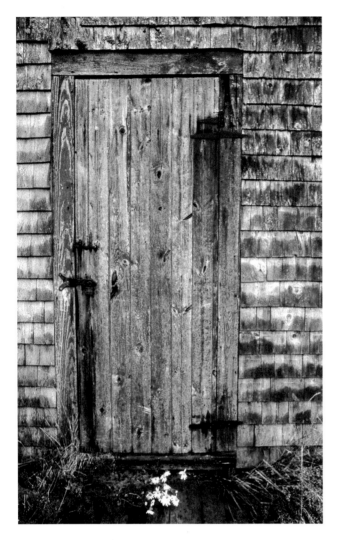

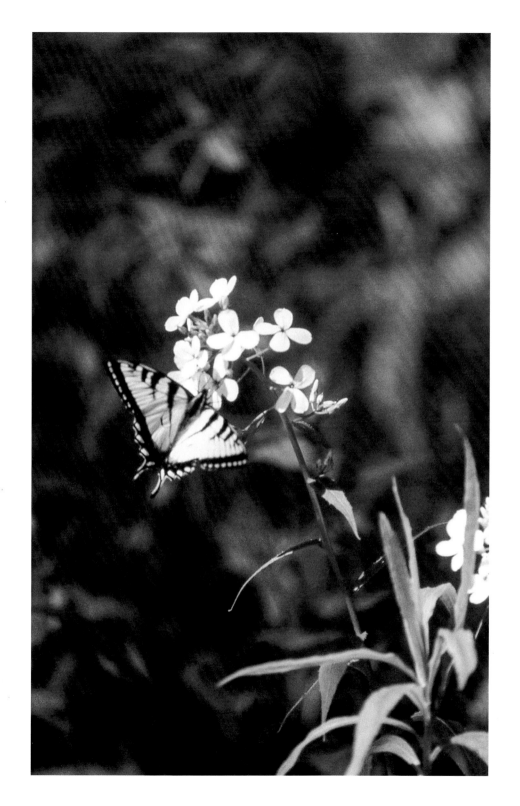

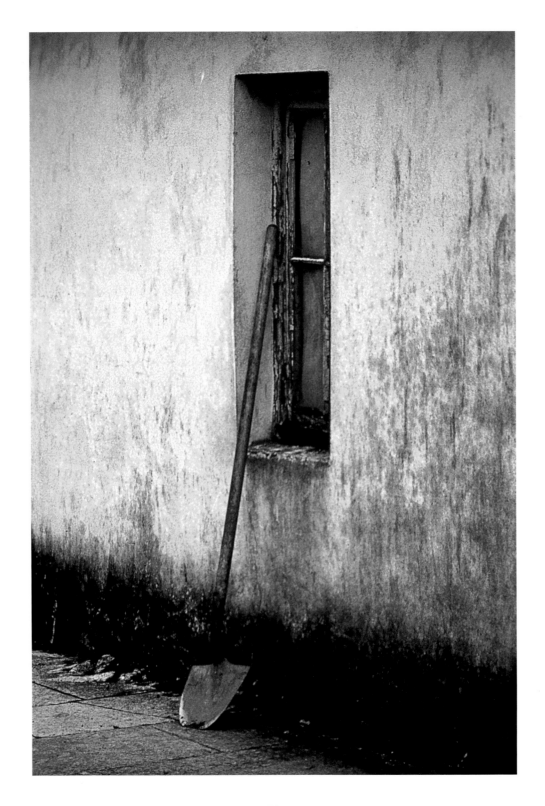

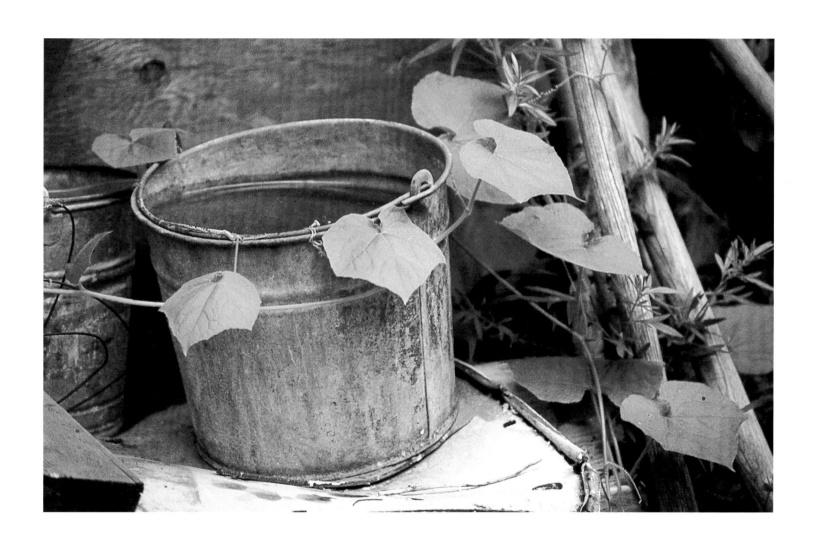

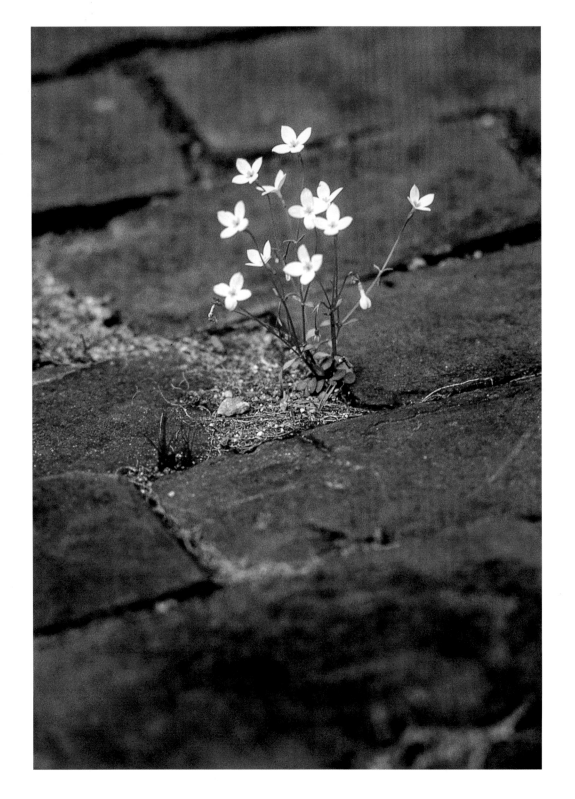

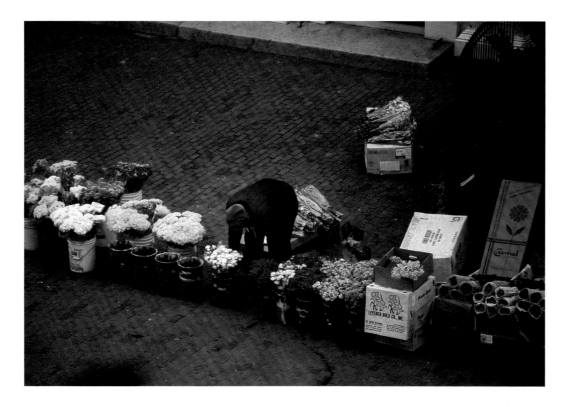

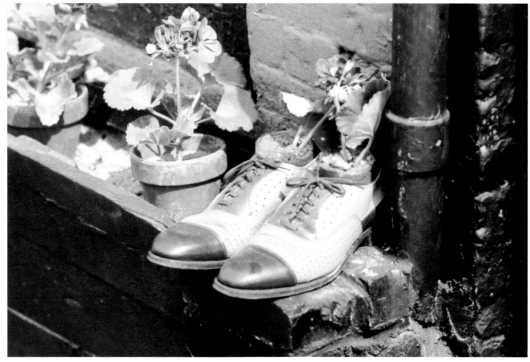

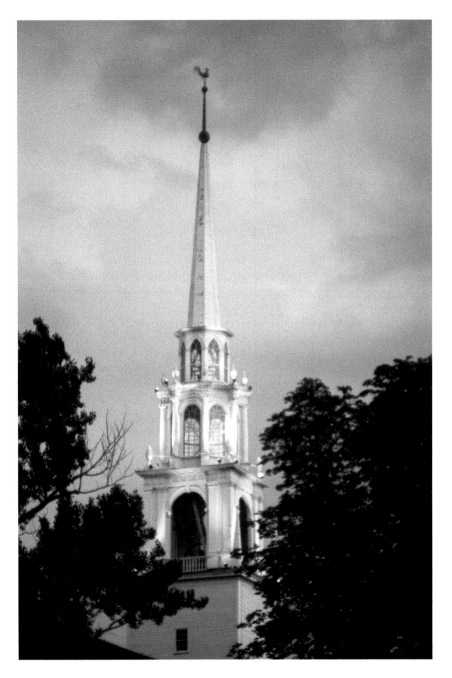

In the Steeple

It wasn't quite to the moon, no;
Just one hundred and fifty feet, or so,
Up there, that steeple, you see;
Higher, yes, than a very tall tree,
Where, while moths flew in the heavy air,
I watched the sun go down, there.
In a mood of wonder, don't you know?
I watched the summer day go.
In my whitened capsule on high
I touched the drowsy, summer sky.

F. M. Dalton
July 1972
Revised November 1972

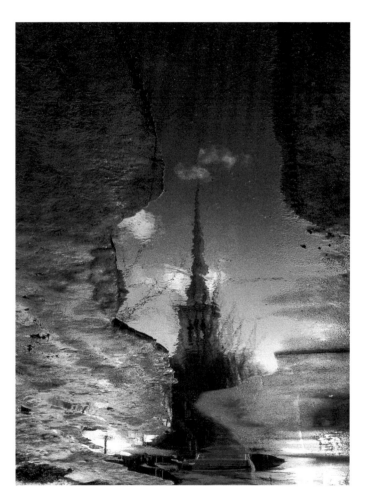

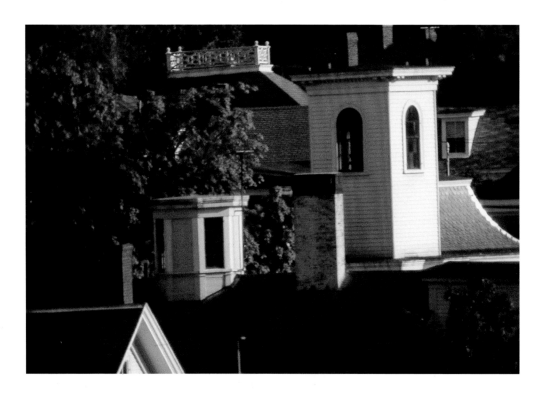

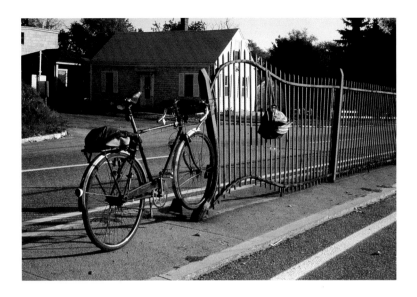

Fences are like folk;
Some are down and broke
Some are fresh and straight
Some are small, some, great,
Some are never touched
Some are daily clutched
By those whose fence
Is a place to sense
The passing world.

F. M. Dalton
February 1974

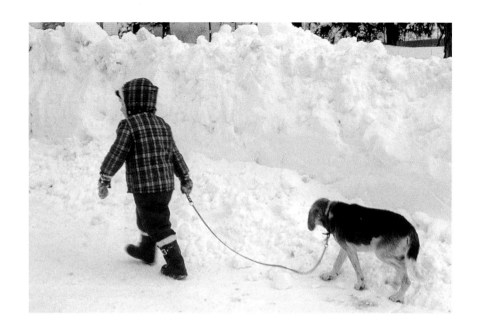

My Dog

Smells – a sewer is sweeter
Doesn't understand when to be serious
Walks sideways
Is as unpoised as a puddle
Can't be loved enough
Has a diamond-hard rear end –
 never wears out from stroking
Never passes up a pile of dogs – or kids
Is smarter than I
And lives well.
He came from nowhere
We're both aimless – he taught this to me.
Has the best sense of humor
Is relentless
Is harmless
Wants only my affection
But takes all things
Where is he?
He's right around here, I'm sure.

F. M. Dalton
1968

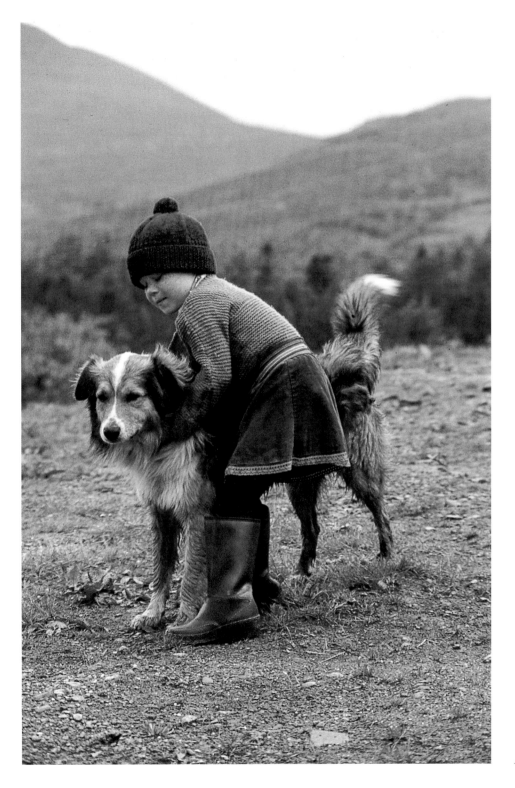

Ireland

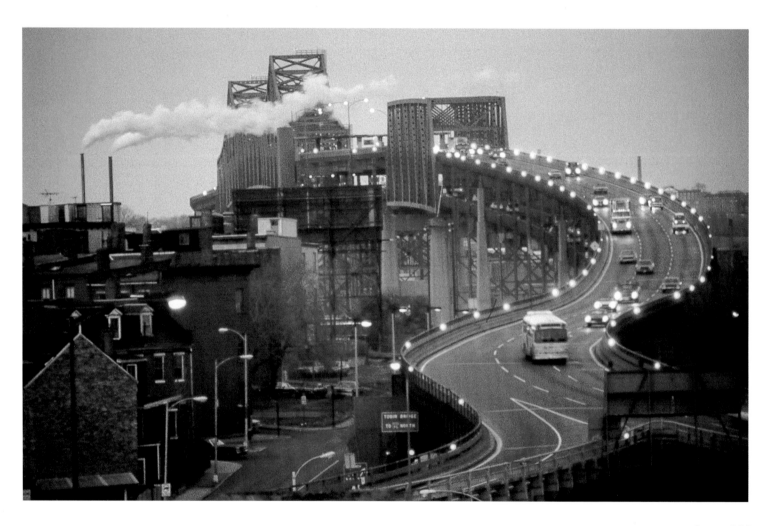

Boston, MA

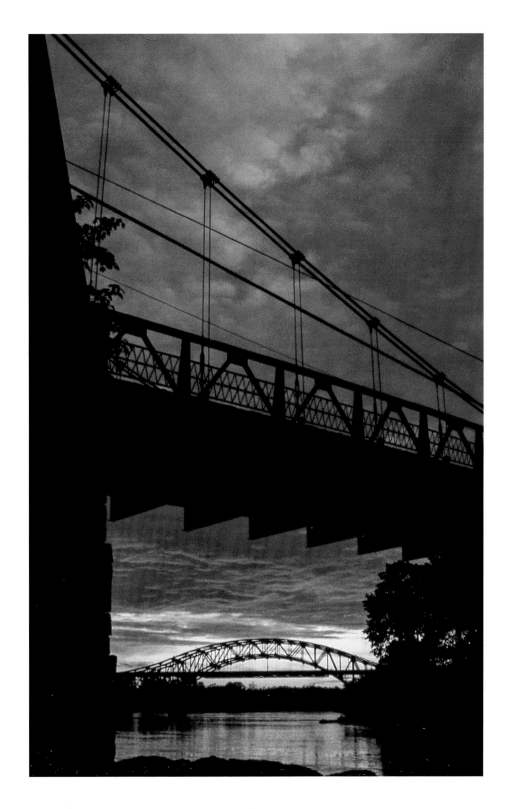

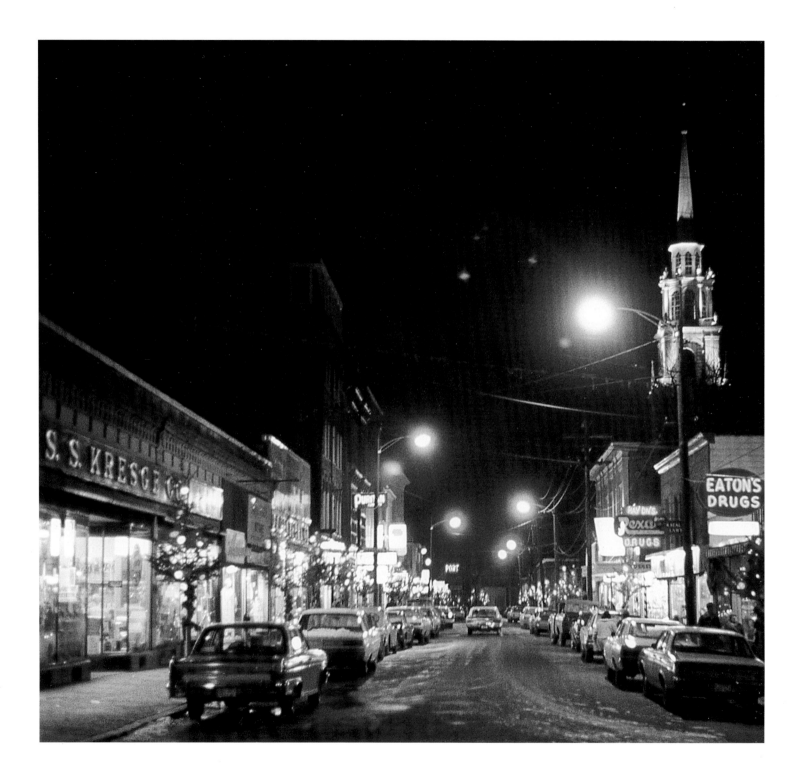

Newburyport is a solid seacoast city (small in size and population), reflecting periods of great vigor. Following World War II, however, it became asleep and was almost destitute until, at the efforts of local people in consort with federal urban renewal and other programs, a remarkable rebirth was effected and the unique downtown was restored.

F. M. Dalton, August 1982
Edited 2021, CHS

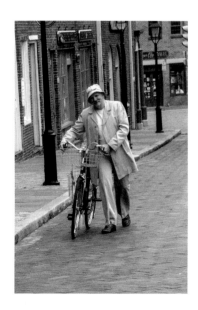

Downtown Newburyport Before Restoration

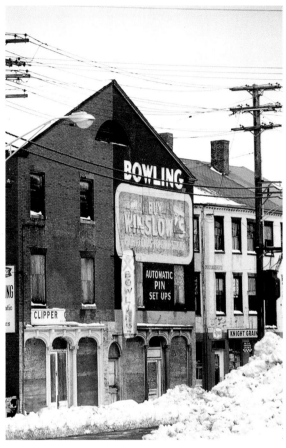

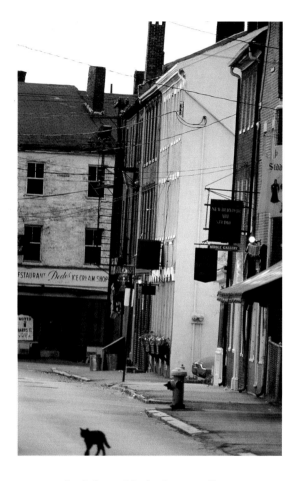

A shaggy, wet cat
Looked over at me
From across the puddly road.
Skinny and matted,
He gazed,
He watched,
As though he was saying,
"I am troubled,
I search for comfort.
Are you some form of that?
Or are you one more
Hazard for me?"

"Don't you know
Child of night
If you come near at hand
I'll try to comfort you, if but by one word?
I'll tell you I know how you feel inside;
I'll make us friends, indeed;
I will.

And the cold, the barren alley-way
The empty canyon of vacant buildings
Will cease to grip and subdue you
For we will be warmed by friendship,
Strengthened by care,
Heartened in each other's touch."

F. M. Dalton
December 1971

Market Square Before Restoration

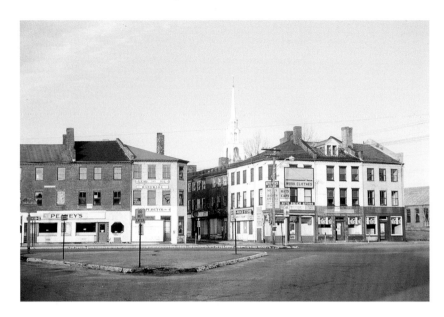

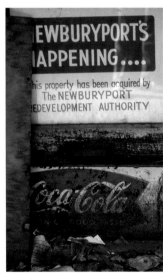

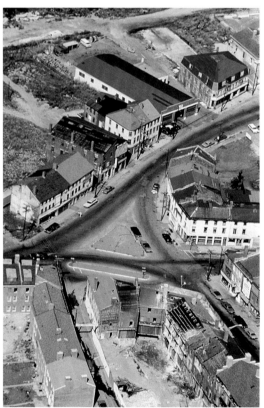

Market Square After Restoration

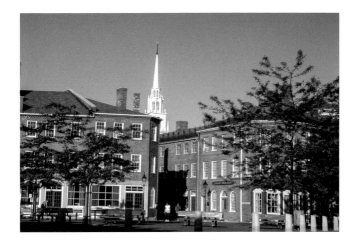

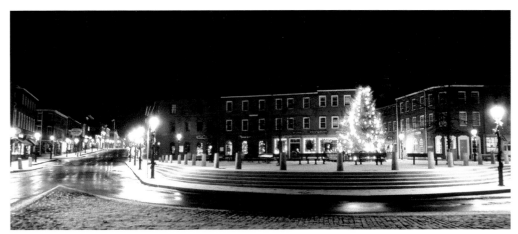

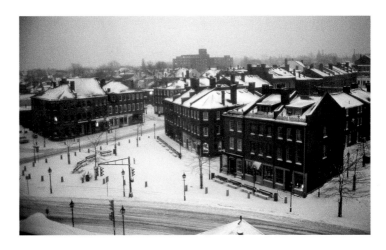

State Street Before Restoration

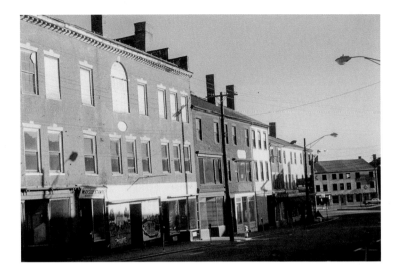

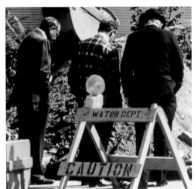

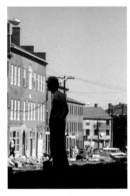

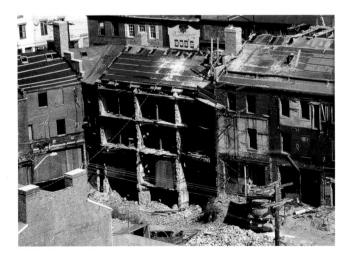

State Street After Restoration

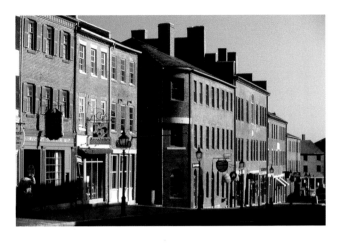

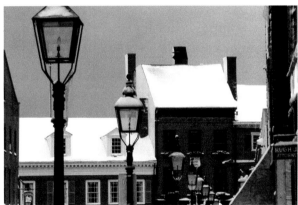

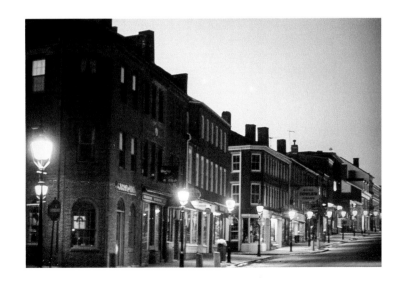

Inn Street Before Restoration

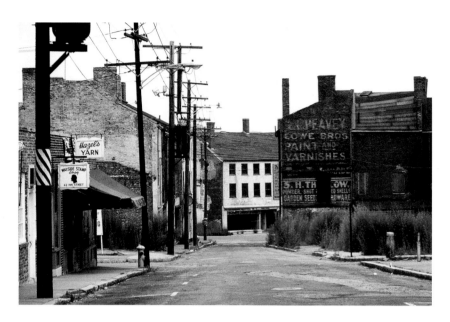

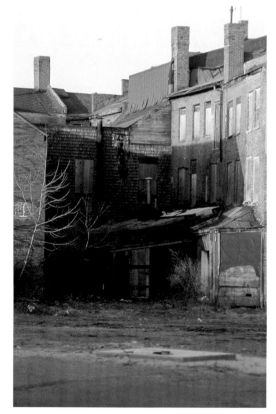

Inn Street After Restoration

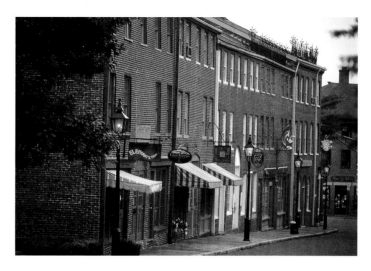

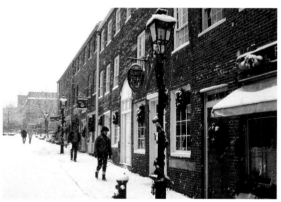

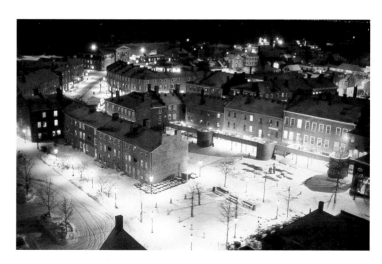

Newburyport from Ring's Island, Salisbury

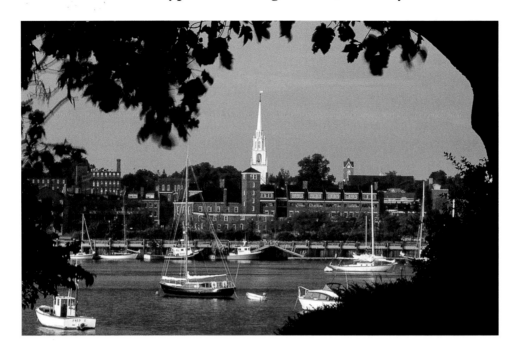

Newburyport from Church Steeple

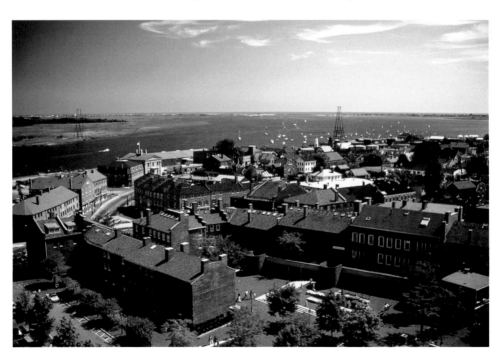

Appendix

Fran's transition letter to family and friends —

11/89

A Note from "Frank" Dalton

I am a female.

If I wrote nothing more than that it would be essentially what I want you to know. After decades(don't ask how many--I lie about my age now)of search I now live out my nature. I don't know how more easily (for you, for me) I could deliver the simple message which, yet, defies description.

Three years ago, with jubilant satisfaction, I entered the land of womanhood, around which I "hung" for all my life, in dismay, most of the time. Three years ago great winds swept me into that realm.

In my return to self I want you to not be pained; just the opposite. I want your eyes to see across a great barrier.

Each one who tunes in on my frequency will receive my message in varying clarities. I have tried and tried, through long nights and days, to conjur a way to help you be comfortable with my present state, that is, living as all my life I've sought to live,as I am, Female. After a long trek across a vast plain during which the rains of agony visited me in great torrents, my truth is upon me now in magnitude, and now, upon you. My spirit has been asked to fly very, very high on little wings and the strength was always at hand. I have done the hardest thing; let go into the abyss of universal love.

How very dizzying and tumultuous it was for me since early youth!- the physicality of man, the mind and spirit of woman; the female self-concept!-and I lingered in the throes of masculinity. Your's is a variation on my puzzlement. You look at me from outside me. For most, I'd say, it is very strange. You need not bolt in reaction. You aren't foreign to living sentiment for you are a creature of this earth and kin to all things, thus, can align, somehow, with me.

Given the society in which we find ourselves, however, a society which long-ago totally blanketed this rare phenomenon from

it's members, places me in a rather spectacular setting. Knowledge of the general state of this phenomenon of body and mind is now leaking into our veiled culture. Gender shift is quite familiar to older civilizations, other cultures. To have learned of them and to have examined the lives of many within and outside my culture has been enlightening and refreshing. Parallels abound.

Theories abound. Theories often abound while experience leaps forward. In his wonderful capacity to analyze, Western man has sought to explain cross-genderism. Psychological conditioning, hormonal insufficiencies during gestation leaving the new-born with a physicality opposed to the mentality, social conditioning are prominent arenas for inquisition among many attempts to locate cause. No small impact on these exercises has been a disposition to assign aberration, illness, depravity to it. I believe this has greatly affected the view, negatively, often placing harmful obstacles in the way of clarity. I don't discount it, but hold it in reserve.

Most parallel to my recognizable experience has been the stories of native Americans, the "Winkte", whose lives I perused. and who felt a spiritual pull of great magnitude. They were "men" who assimmilated into the female place. These women were welcomed, revered among their population, who wasted nobody.

As I said, theory and practice often walk apart. I emerge from the tangle with powerful instincts. Among theories, amidst a jungle of intrigues came my clear experience from a wondrous place but, I cannot, even after a multitude of efforts heretofore, give you much in this message. I can only tell you of it's integrity, of my release from a prison and ask you to take time, be open and compassionate with yourself as you bump into questions, feelings which will dot these hours. These are valuable hours. Growth is at hand. Abide the pain of it and don't manufacture pain. Be wary of "labels", attempts at ready-classification which can not only miss the mark but also wipe out"shades of gray", i.e., variations on a broad notion.

Quite consistently, from the early hours of youth when the tumbling clouds of unrest boiled above my spirit, until this very hour, has my eye watched with hard scrutiny, testing my longing for signs of whimsy, giddy flight. Onward, nonetheless, through incredible ordeals sped my spirit far into the realm I sought, to me, the finding of who I am.

3

Some of you, maybe all, might feel a loss among sentiments which will arise. Yes, I embraced manhood with a ferocity and those years of effort brought me close to the grand "council fires" of manliness. Man is superbly beautiful; a wondrous creature. I, too, mourned my departure from his identity. I came close and the fire was brilliant and warm. Consider the genderless panorama of human spirit. It is a vantage point of great value. My life on earth, it so happens, has a female accent. The central axis of beauty is not of gender. Be gentle of all things and know that I am more present than ever.

Each of us carries truth in us. When the gifts of courage and faith strike "just so" we can "feel the wind on our wings", exhilirate in life's motion which, really, is always at hand. We do live our truth. How long, in so many phases of my life, did I have to wait before my "wings" spread. Moments came, however, when I leaped aloft, let go my torments and darkness, and soared. Such is now.

To ramble on, now, into volumes of discourse feels inappropriate. I give you this to soften your eyes, your mind and to eventually celebrate with me. I accept, abide any response. I ask not to stand among you except when the "groove" is open. Then, I shall slip in. It is not fun to observe closed-mindedness, narrowness, hostility, negativity but these exist and are the best resolution for some. I'm OK. I wish for you to be as close to peace as I can nudge you.

I cannot, alone, carry the load we all bear, of learning to navigate beyond not only the inheritance of toiled thought, but also to evolve, as you will, to "spread-wings and racing winds and dizzying heights." We are, wondrously, plying our own course to destiny. I depend on human integrity. I have no real enemies, just neighbors, sitting by their own light as I do, seeking, as do I.

Image Notes

Page 1:

Built in 1823, 1 Market Square was occupied as a market and public hall. In the mid-1800s it became the Central Fire Station for Newburyport until 1980. Presently, the Firehouse Center for the Arts, a nonprofit performing arts theatre, offers many cultural events throughout the year in the beautifully renovated firehouse.

For further information:

Institutions For The Ages, Dyke Hendrickson, *Newburyport Daily News*, January 28, 2014.

Pages 50–51:

Fran's studio was located off the beaten path in Newbury, MA. She called the little hollow "The Digs." In her later years, she spent many hours in her garden growing award-winning pumpkins and caring for and photographing the chipmunks and rabbits who were her companions. Fran's sense of humor was on display with the characters she created to share the Digs with her.

Page 52:

The Broadway Flying Horses were hand-carved by Charles I.D. Looff. The carousel opened at Coney Island, New York City, in the late 1800s. In 1914 it became a beloved attraction at Salisbury Beach, MA, until 1977 when it was sold to a San Diego, CA, firm that operated it until 2004.

For further information:

'Broadway Flying Horse Carousel' has Storied Past, Angeljean Chiaramida, *Newburyport Daily News*, April 4, 2017.

Page 76:

Duncan Chase was a fixture in downtown Newburyport, often occupying a bench in Market Square. Fran befriended Duncan and photographed him often. His addiction to alcohol was well known. When he passed, at the age of sixty, Fran arranged for his burial. Duncan's favorite saying, "I'm a cool, cool cat," which he often shared with passersby, was inscribed on his gravestone. *An Ode upon Duncan's Homecoming* was both a recognition of Duncan's struggle and of his inner "gleaming gold."